CROSS SECTION
Glasgow international Festival of Contemporary Visual Art 2008

Edited By Francis McKee and Louise Shelley

Designed by Robert Johnston

Printed by Beith Printing, Glasgow

ISBN 1-873331-32-0

Published April 2008 in an edition of 1000 by The Gi Festival 2008

In association with:
CCA, 350 Sauchiehall Street, Glasgow, G3 2JD

Glasgow international Festival of Contemporary Visual Art 11–27 April 2008
www.glasgowinternational.org

The editors would like to thank
Robert Johnston, Kate Davis, Luca Frei, Babak Ghazi, Melanie Gilligan, Alasdair Gray, Fiona Jardine, Jan Verwoert, Faith Wilding, Rhona Warwick, Sorcha Dallas, Bookworks, Continuous Project, CNEAI, Jean Cameron, Vicki Anderson

Glasgow:
Scotland with style

Contents

Introduction

CROSS SECTION IS THE first catalogue for Glasgow international and, as such, it seemed appropriate to celebrate the role of creative writing within the field of visual arts. It is an activity that is increasingly practised by artists in the city and elsewhere, perhaps because it allows access to a conceptual space beyond commodity or commercial and institutional pressures. It is at once a very intimate and public medium and it shadows the material world of practice, investigating ideas, challenging received wisdom and pushing at the boundaries of art.

We have asked a selection of both local and international artists and writers to contribute to this catalogue. What is clear from their submissions is that creative writing within visual arts is a broad, experimental field. Ranging from philosophical polemic and artistic dialogues through autobiography to fiction, everything seems permissible. It may not be a coincidence that this field has broadened as mainstream publishing itself declines into celebrity blockbusters, but it seems timely to acknowledge the growing importance of this strand of visual arts.

Cross Section also functions as a snapshot of Glasgow's art scene in 2008. There have been many changes in the city's landscape recently but the list of projects and events listed here demonstrate the existence of a remarkable community of artists and organisations operating at an ambitious level.

This year's Glasgow international is the largest to date and the first in the festival's new biennial format. It marks another stage in the rapid growth of this event and, as before, it is clear that it succeeds because of the willingness of everyone involved to work together. This includes the funding bodies who deserve a special mention because of their supportive approach to the festival and their immediate understanding of the value of the city's grassroots arts organisations. As always, it is those organisations and the artists involved in the festival who are its driving force.

Obsolete Introduction to *A Life in Pictures*

Alasdair Gray

In small countries the artists are very versatile. The smaller the country,
the greater the versatility.
Tadeusz Konwicki in *A Minor Apocalypse*

I GREW UP in a house containing many books with pictures in them, some
of which were read to me. My mother's favourite art (apart from baking and
housewifery) was song; my father was a keen hill walker and climber who never
claimed to have artistic talent. Yet they gave me pencil, paper and crayons be-
fore I learned to read or write and were pleased to see me using them. Most
educations kill the childish faith that anything we want can be ours. It is mainly
due to my parents that my education left me sure that I could make anything I
wished in words or pictures, if given the time and materials. I was also fortunate
in schools where teachers of literature and art also encouraged my talent. Like
my parents they also explained that making a living by painting or writing in
Scotland was practically impossible for someone not getting money for other
work, or from inherited wealth.

'An artist who depends on art for his living must be an advertiser', wrote
a Jewish Cockney painter in 1915. Not being an advertiser Issac Rosenberg
concentrated on poetry, joined the army and was killed in France, one of that
slaughtered and shell-shocked generation whose works would have made the
economic depressions between two World Wars less depressing. I belonged to a
cheerier generation born at the end of 1934. My childhood was under a Conserv-
ative coalition government so keen to beat Hitler's Nazi empire that it unified
Britain, using Socialist measures it had rejected as revolutionary in peacetime.
In 1944 its last great act allowed anyone to get higher college educations if they
passed the entrance exams: those unable to pay for food and housing while
studying were funded (like civil servants and the army) out of the public purse.

That good act let me enter Glasgow School of Art at the age of seventeen.
Here, like many others, I enjoyed studies which had once been the privilege
of folk from richer families. So great was my pleasure in drawing and painting
that I hardly noticed those who found the results puzzling and ugly. I made
friends with fellow students who I regarded as colleagues—painters who took
it for granted that art would be a struggle, not a steady source of income. Yet on
leaving art school with a Scottish Education Department Certificate in Design
and Mural Decoration I hoped, like Rosenberg, to live by my art through adver-
tising it. My big wall and ceiling paintings would advertise themselves, being
rarities in Scotland. Exhibitions of smaller work would bring useful publicity
and sales.

Alas my grandest mural was in an east end Glasgow church that could only pay for the paints and brushes. It was on walls no newspaper critic saw, no dealer could sell or collector buy. For thirty years I showed pictures in nearly thirty group and one-man exhibitions, two of them big retrospectives. The last travelled at my expense from Glasgow's McLellan Gallery to Edinburgh's Talbot Rice Centre, then to the Municipal Gallery of Aberdeen. These shows never sold enough to pay their costs, had little or no attention from the press and broadcasting services, attracted no offers from professional dealers. I was saved from a deadly sense that my art could please only me by some friends who liked, bought and commissioned it. One of the most generous, Elspeth King, believes they were widely ignored in Glasgow because my first mural, at the height of the cold war, was in the Scottish-USSR Friendship Society, after which I did unpaid work for the Campaign for Nuclear Disarmament. I can think of two other reasons.

My pictures were mostly dark, dour and turbulent, full of energy and invention but not delightful. A rich art market, of course, can profitably sell a dead sheep in a tank of formaldehyde, arrangements of empty cardboard boxes and other undelightful things, but Scotland has no rich art markets. Before the First World War Glasgow had a brisk one that dealt internationally. In the 1920s it vanished with several other local industries, since when our only painters to sell well have first exhibited abroad or in London. I therefore belonged to a mob of numerous unlucky Scottish artists, several painting (I thought) in some ways better than me, though differently. Many of the best would have been as indigent had they not also been teachers.

I too at first subsidised picture-making by part-time teaching then by unpainterly makeshifts too many to list. Writing became one of these and at last the main one. In 1981 Canongate published my first and biggest novel with exactly the typography and illustrations I wanted. The Scottish Arts Council gave it a design award. While planning my next book, a collection of short stories, I started imagining my life's work eventually appearing in six splendidly printed volumes.

STORIES

LANARK (The Novel)

POEMS

PICTURES

PLAYS

ESSAYS

One volume would reproduce my best pictures. The book of poems would be as tall, every verse being surrounded by a unique illumination blending the styles of William Blake, Aubrey Beardsley and the *Book of Kells*. I explained this project to Stephanie Wolfe-Murray, then the director of Canongate, who gave

no sign of the scepticism she possibly felt. I said that years would pass before these books were ready to stand side by side: I would likely be senile by then and spend the rest of my life collating a volume of remarks about other people's books entitled *Pottering Around my Shelves*. 'Yes,' she said sadly, 'and Canongate will probably make more money out of that than any of the others.'

This project soon became impossible because one of my stories swelled up into a second novel and was followed by others. *The Scottish Existential Book of Kells* became two slim volumes of verse, the *Collected Essays* split into political pamphlets and a heavy anthology with marginal commentaries. No publisher is interested in my plays so I am putting them on a website.

But here at last will be my picture book, though not the picture book I once imagined. That would only have shown completed works after I had restored all those that were damaged and completed all those that were less perfect than they could be. When Nick Carroway tells Jay Gatsby 'you can't bring back the past,' Gatsby replies astonished, 'Of course you can.' In life Nick is right, of course, but in art Gatsby is right. I have often picked up neglected, damaged work after many years, making them good and new. Most of these pictures were small. I thought a chance to renew all unfinished or damaged mural decorations appeared in 2000. The public lottery fund, in alliance with the Scottish Arts Council, ran a competition open to every sort of well known Scottish artist. We were invited to submit plans for ambitious projects in arts where we were not well known. Ten winners would have their projects funded out of the public purse with living expense while they executed it. I was then known as a novelist in Britain and overseas, but only some people in Glasgow and Dunfermline knew me as a muralist, so I submitted a plan to restore and complete five surviving mural decorations. A referee for my application (Duncan MacMillan of the Talbot Rice Gallery) privately told me I would have a better chance if I applied for funding to retrain as a ballet dancer. Perhaps he was right. My name was on a shortlist publicised by the selection committee before they announced the ten winners, finally rejecting my project because it was not in an art new to me.

My *Life in Pictures* shows work too inconsistent to put me beside great 20th century painters like Stanley Spencer and Edward Burra, though perhaps the best of it may let me be listed after John Quentin Pringle and James Cowie, who also had mainly to paint when on holiday from other work. I may even be allowed a footnote in art history alongside Benjamin Haydon, Mad John Martin and William Dadd.

A Life in Pictures will be published by Canongate in late 2008.

Excerpts from

The so-called utopia of the centre beaubourg

An interpretation

Luca Frei

PACO. A CHUBBY CHILEAN, arrived in Paris before 1973, studied Fine Arts for a year, subsequently did small jobs, drinking red wine into the night with the ladies, increasingly losing the hope for a change in his country as more and more time passed... He's been at the beaubourg since the beginning, but never got fixed on a particular activity. He waits, and observes. And one day, he started to talk, not in a meeting, but to individuals, one at a time, especially to busy ones, to those who continue to go down to their studios at fixed hours and regularly come up some hours later, reproducing down here the routine rhythms of the industrial schedule. Without wearing a watch, they have internalised their schedule to such an extent that they don't need to ask anyone for the time to know when to start and when to finish.

Paco's big idea, which would become his own crusade, is to stop all the watches, to mess with the clocks, or even to get rid of them.[1] Down here he won't find much to do — since there aren't any clocks — except to take some of those with conditioned rhythms with him and to try to decondition them from their routines and to fight against the routines of others.

All of a sudden, el gordito became super active, starting revenge expeditions against all forms of time measuring; wandering into the underground during busy hours with a large magnet hidden inside a newspaper under his arms, he approaches travellers and stands close to them to deregulate their delicate wrist watches; he does the same with public clocks by fixing magnets to them with some tape, or by simply putting up a sign saying: OUT OF TIME or BROKEN or LATE, or on the bus and train timetables — TIMETABLES SUBJECT TO CHANGE or THE BUS WILL NOT LEAVE UNTIL FULL or, going further, THE PERSONNEL WILL BE GLAD TO INFORM YOU — other times he fixes signs of a more educational character: TO MEASURE YOUR TIME IS TO SHORTEN YOUR LIFE — DO TOMORROW WHAT YOU THOUGHT OF DOING YESTERDAY — RELAX, YOU'RE NOT LATE.

· · ·

The first children to have chosen their parents live here in the centre. At present I have a good dozen and Maximale, my long-time partner, has as many. Mine are often with me and absorb a good deal of my time, especially the three that started woodwork and that haven't found someone that can teach them better than I can. Last night another one came back and we ate and slept close

for me, I stop right here
th this ugly and useless
mbering of pages, to the
nefit of the idiots who read
o fast.

to each other. 'I missed you and came looking for you'. He's 12 and had stayed with me for two years, straight after the opening of the beaubourg. Then, last year, he went to live in one of the 'homes', a sort of gathering of tents and mats on the 19th level. At that time his name was Christian, that's probably how he was registered at his birth. And as I've thought about him with this name, it's not easy to now call him Omar (the last Israeli-Arab war introduced the trend for this name). Besides, but perhaps it's simply a consequence of my age, I have a certain difficulty to get used to these changes of first names; I'm still used to identifying my feelings for someone with a proper name and I find it difficult to get to grips with the fact that the name of a person doesn't belong to her or him but is given by their friends, to mark a specific, profound relationship between them.

We won't own anything, even our name, we won't live but for others and it will be this brotherhood that will give us names, and we'll have several names because we'll have brother- and sister-relationships, each one of a different quality. Everything belongs to everyone and everyone belongs to everybody. I belong to you as you belong to me, and what is in you is also in me. So I'll continue to call you Christian.

. . .

The culture that we want to create can't be reduced to painting, to literature, to the fine arts. The new culture is as much about a way of painting, as it is about a way of shitting. To break the straitjacket of established values. The search for 'real values' is always used to mask the legitimisation of power and, as for me, I'm beginning to think that there's a profound relationship between 'moral values', 'cultural values', 'French values' (or those of other nations) and market values; basically in general it's the same people who defend the one and the other.

. . .

On that very Christmas morning, I discovered our first activity, not without surprise. While I was descending, someone told me: 'there is a strange din down below, as if they are driving motorbikes'. Indeed, some bizarre noises were coming up through the lift shafts. I had to stop at various levels before discovering, on the 62nd floor, about 50 motorbikes of all kinds and sputter. As usual most of them were running stationery, waiting to be pampered by their caretakers. What an echo! They must have occupied this level for several days, as a lane was clearly marked on the ground and the walls were speaking. In big characters: MOTOR = CULTURE. 'Luckily,' I came to think, 'the elevators aren't big enough to transport cars…' Some of the bikers recognised me and approached, their pace that of the proud lord, although they felt a bit like squatters all the same.

— We were at the meeting the other night, when you said there wasn't a fixed definition of culture. For us, it's the motorbike, and we thought we had the right to come here. Furthermore, it is freezing outside, we don't know where to go and the cops are chasing us everywhere.

I simply tell them that, personally, I don't mind and that I am actually delighted, but that they will have to defend their point of view at the general meeting and that, perhaps, they should get organised...

— We already are, continues the same guy. Here we are in three gangs, we have nominated leaders, it is forbidden to smoke where we keep the tanks and to ride on the escalators: we've even expelled two guys for doing that.

A bit rigid as an organisation, but it holds. Later on they would descend to the 75th, which not only had the advantage of reducing the noise but, most of all, because of their position, these last levels, technical levels, allowed a better ventilation and a safer storage for the fuel.

The Motorbike was our first cultural activity and, luckily, it was sufficiently marginal compared to Culture with a capital C, to encourage other scatterbrains to get organised. Thus, we soon had diet groups, yoga brotherhoods, as well as other groups, sects and bizarre cults that I'll talk about later. Well understood, all this at the margins of 'true' cultural activities, legitimate in the eyes of the Cultivated and of those that incarnate great Culture. These recognised activities, labelled as cultural, such as painting or theatre, in the meantime took off less rapidly and they, in small groups, had the tendency to immediately raise issues of financial support, taking on as their core the old attitude of begging, a result of the parasitism in which the rich and cultivated minorities always kept them.

Architects and teachers have this in common: they protest against a restraining society but they don't take the time to impose their own point of view on the people whose behaviour they mould, an inhabited model for one, a cultural model for another. These are the two types of moulders that we have to deal with.

The first to confront were of course the architects, who didn't understand why we left so much space without precise attributes. They do it in urbanism, in housing, in cultural buildings; they pretended to come and help us to define the different functions of the rooms architecturally: here we'll dance, there we'll rest, and there we'll run, etc. In other words an exact replica of what they impose in the cities and the complexes they build, where the people that will live there know in advance where they will and, especially, where they will not sleep, or run, or eat, etc. All these impositions and intrusions on the lives of those affected are naturally accompanied by the usual salad of the Freedom of Man and the humanism of the devisers. When will these naïve monoliths realise that they are the most reliable spokespeople of the integrated society, that their moderate audacities and their pathetic concrete doesn't help but fool themselves?

The ancient cities were lively precisely because they weren't planned: houses and streets were built and paved little by little, according to necessity, a room or a wing was added, or a street was opened when more space for circulation was needed. We'll do the same: we'll be anti-planning, anti-urbanism, non-architecture. And like in the cities from the past, rooms will have double functions, there will be badly used spaces, lost corners, and we'll make changes when we think it's time, and you will not build us amphitheatres, nor orchestra pits, nor boxes for audiences or music halls, nor photographic laborator-ies. The floors will be divided according to activities and fantasies, and since Dylan doesn't bother me when I visit Webern, their vicinity doesn't matter to me. Unavoidably, there will be wavering, indecision, discussion and tension: however, let's have these discussions between us, the interested (and not the inter-stressed, those whom you surround with your benevolent advice); because we also know that we could never have these discussions with you, since the planners never speak with the planned, the modellers with the modelled.

I am about to start hating the sitar, to hate the guitar and its electricity, the charango, the pan flute and the Alsatian epinette, the gong and the snog, the calebasse and the pan: BECAUSE IN THIS HOLE WE CAN'T HEAR OURSELVES ANY MORE. Sometimes up to five groups per floor, without counting the isolated ones that scratch, clear their throats or whistle in their own corner. How to stop this diarrhoea of sounds? And just yesterday, I was cursing the architects and their pre-imposed solutions; at least they would have confined the noisy areas or made some auditoriums or soundproofed concert halls…

And yet, we have to curse them, because the direction that we have taken is the right one: the concerned, those who disturb each other like those who need their own loudness saturated, will together find rules of conviviality. A good sign already: the musicians have decided to leave the 29th floor to the theatre groups.

We have always been put under pressure to follow certain directions, to obey, and to conform ourselves. Sometimes society, that is to say those who hold the power, are more subtle and ask for our adherence, until they make us obey 'freely' to the rules they insidiously decree for us. But we'll get there, today with our musicians, tomorrow with our meetings, with our sweeping and the eating, with all that makes our life and we won't accept other rules than those that we'll proclaim and that will be the foundations of the new culture.

The so-called utopia of the centre beaubourg is the second in a series of co-publishing partnerships, entitled Fabrications, initiated by Book Works. Published by Book Works, London and Casco, Office for Art, Theory and Design, Utrecht, 2007.

What becomes art?

F. Jardine

Under the existing dominant society which produces the miserable pseudo-games of non-participation, a true artistic activity is necessarily classed as criminality. It is semi-clandestine. It appears in the form of a scandal.
Manifesto of the Situationist International #4

RECENTLY, BANKER JEROME Kerviel engineered a spectacular billion dollar detournement at Societé Generale through a complex series of unauthorised and fictitious trades. His 'perverse and intimate' knowledge of the bank's risk control systems allowed him to avoid detection as he went about his business. His behaviour perplexed the bank's director, who stated Kerviel had 'no rational reason to exceed his authority'. Acting alone, for no apparent personal pecuniary benefit, the 'computer genius' seems to be a particularly French, particularly contemporary anti-hero. We can recognise him, the reported bleakness of his social life, (11 fairweather Facebook friends), his absurd number-crunching career—'You lose your sense of the sums involved when you are in this kind of work. It is disembodied. You get a bit carried away'—from the writings of Michel Houellebecq, and we can recognise his crime as art: aesthetics allow for both.

'Literature always anticipates life', writes Oscar Wilde in 'The Decay of Lying'. Applying Wildean logic, Kerviel is as inevitable as a boy burglar:

> simply... the result of life's imitative instinct. He is Fact, occupied as Fact usually is, with trying to reproduce Fiction, and what we see in him is repeated on an extended scale through the whole of life.

This dictum—that life imitates art—often pre-empts censorship: Wilde's boy burglar steals fruit after reading Dick Turpin adventures as teenagers joyride after playing *Grand Theft Auto*, it seems, or murder after listening to Marilyn Manson. Wilde, though, with an avowed and passionate disinterest, with an all-encompassing, liberating aestheticisation of life, does not stand in judgement, he just makes the observation. In doing so he points to art's paradigmatic function, it's role in positing markers and characters, in offering propositions for recognition and negotiation as well as blunt activation.

The moral panics thrown up in the wake of fearful links between art and crime serve to illustrate how close the relationship between the two can be. Some, Situationists for example, believe it to be a necessary and unavoidable one because legislation evinces alienation, something deliberately promulgated by power-elites: ignoring or flouting it is a liberating and creative act. Hakim

Bey expounds a theory of 'Temporary Autonomous Zones' (TAZ) which exist beyond or between legal constraints. In these zones, legally sanctioned behaviour is controverted. 'Poetic terrorism', which forms a central tenet of Bey's conceptualisation of TAZ aims to change an audience's perception of existence through spontaneous intervention:

> Weird dancing in all-night computer banking lobbies. Unauthorised pyrotechnic displays. Land art, earth-works as bizarre alien artifacts strewn about State parks. Burglarise houses but instead of stealing leave Poetic-Terrorist objects

If these strategies seem familiar now, it is more likely to be from mobile phone ads, the daft protesting of the Clown Army or the comedic meanderings of BBC3 personalities, (Dave Gorman, Danny Wallace etc.), than from the musings of a radical anarcho-mystic like Hakim Bey: fluffy illegality and poetic terrorism rapidly become 'random acts of kindness' or 'chicken soup for the soul', not situationesque engagement as Bey intended in 1985 when he published TAZ.

Similarly, artists like Jochem Hendricks, who treads the boundaries of legality lightly, shoplifting for exhibits and displaying the bodies of dead (outlawed) fighting dogs in galleries, skirt around the issues of art and criminality in a pseudo-situationist fashion. Though technically illegal, Hendricks's very literal approach merely illustrates a subject — crime. In this respect, his work is essentially formalist. His intention is to make a verifiable 'art product', which he does, and which you could have seen in Haunch of Venison, London last September. His work may be (mildly) diverting, but it is not paradigmatic, and when 'art' does not operate at the level of paradigm, it does not operate at all.

Paradigmatically, criminality manifests itself both in the figure of the artist and the activity of art through the notion of transgression. Besides a rogue's gallery of verifiable artist-criminals that might include Jean Genet and Caravaggio, as well as accidental criminals like Vito Acconci and Chris Burden, the popular stereotype of the artist as deviant — mad man or criminal — is persistent because, at root, crime, art and insanity challenge social constructs, definitions and boundaries. In Greek myth, Prometheus, in an archetypal act of human creation, stole fire from the gods. There is a biblical parallel in the figure of Eve. Prometheus is the prototype creative innovator and transgressive personality from whom Romantic ideas of the artist derive, (Eve is neglected, even vilified). Sisyphus, condemned to an eternity of frustrating drudgery perpetually rolling a rock uphill, is an Existential creator. According to Camus, he can effectively negate his sentence by loving his task, creating notional freedom at least. Prometheus's transgression is physical, his creative act is prohibited action; Sisyphus's transgression is mental, his creative act is prescribed thought. At some level, Sisyphus is a proto-situationist actually realising artistic energy in life, even if the necessarily private nature of it does not permit broader cultural repercussion.

Naturally, the notion of transgression raises questions about morality: In 1988, Mike Kelley produced his own rogue's gallery, 'Pay for Your Pleasure', which married huge monochrome portraits of artists, poets, literary figures and others with quotes attributed to them on the subject of the similarities between criminality and creativity. At its core, the installation featured one of John Wayne Gacy's clown paintings. The Renaissance Society of Chicago, which commissioned the work, comment:

> It is hoped that in this confrontation of our recognised creative geniuses and a recognised mass-murderer that the absurdity of Gacy being an artist—as well as his grossly unfortunate notoriety—will be revealed. With this, we, as members of this community, can ask which of our institutions and desires are responsible for confining Gacy as a criminal and yet freeing him as a celebrity.

Which was a pipe dream for the Renaissance Society, for neither art nor celebrity admit morality, though people expect them to. Criminal intent may not be commensurate with creative or artistic intent, but the apprehension of crime can provoke an aesthetic response and therefore perform as art. In 1827, Thomas de Quincey wrote 'On Murder Considered as One of the Fine Arts', and imagined a Society of Connoisseurs of Murder:

> they profess to be curious in homicide, amateurs and dilettanti in the various modes of carnage, and, in short, Murder Fanciers. Every fresh atrocity of that class which the police annals of Europe bring up, they meet and criticise as they would a picture, statue or other work of art.

They were not involved in the procurement of murder, and did not perpetrate murders themselves, they merely discussed and appreciated them: murder was subject to the governance of an aesthetics developed, augmented and modified by the Society as detached observers. It is this distance, aesthetically produced through the involvement , which is necessary to the appreciation of ordinary (and extraordinary) events as art. Stockhausen was condemned for his remarks that the 9/11 attacks on the World Trade Centre represented 'the greatest work of art imaginable for the whole cosmos'; who can deny the shift in consciousness it effected, or the iconic televisual images it produced? It is certainly impossible for anyone to deny Stockhausen his aesthetic response, even if his claims for the whole cosmos were a bit overstated: 9/11 performed as art for him.

The question of intent is an interesting one, both in crime and art, both in commission and reception. With the readymade, Duchamp appeared to prioritise the intent of the artist over the nature of the object: subsequently, this priority crystallised around the notion of institutional 'white cube' contextualising. However, Duchamp also imposed an active duty of intent on the viewer—the willingness to see an ordinary object in a gallery as art, thereby contributing to

the realisation of the whole work. The 'readymade' does not even exist without the viewer—what exists is an ordinary object in a gallery. Duchamp may have had to use an institutional context to effect the readymade, but its true legacy is in the creative potential of the viewer, not the affirmation of the hegemony of gallery or museum. In this respect, the readymade should be considered as contributing to the tradition of the Baudelarian flaneur, (the flaneur being an analytical connoisseur of urban life): for Stockhausen, 9/11 is a readymade.

It is this idea of active viewing, perhaps in determining readymades, perhaps psychogeographically as a quasi-flaneur, that really carries the Situationist agenda forward, because Situationist culture:

> introduces total participation... it is the organisation of the directly lived moment... (in which) everyone will become an artist, i.e. a producer-consumer of total culture creation.

Nicolas Bourriaud makes claims that his theory of relational aesthetics 'updates' Situationist ideology—'relational' art in his formulation deals with the whole sphere of human relations and their social context. To this end, Bourriaud harbours an unfounded ambition: for all the supposed contemporaneity of relational practices, reliance on the contextualising power of art institutions, agencies and professionals in Bourriaud's analysis perpetuates interpretive elitism, something which has characterised authoritarian establishments and attitudes—the Church, the Law—for centuries. Introducing 'total participation' is not a question of simply taking behaviours that exist outside the gallery into it in order to formalise them: it is through the encouragement of active aesthetics. Art, as such, can only hope to provide paradigms that assist the viewer in organising the directly lived moment to become a producer-consumer of total culture-creation, an active aesthetician.

The Emancipated

or Letters Not about Art

Melanie Gilligan

... some kind of elemental process is taking place where the living fabric of life is being transformed into the theatrical.
Viktor Shklovsky

THE ARTIST DREAMS that he is at an average mid-week art opening. Growing tired of the person he's speaking to, he makes an initial move to get away but finds the physical effort he made was too great. He has propelled himself through the air, shooting backwards through the sky, away from the earth, through a tunnel of clouds rising higher and higher, passing through thresholds of conscious thought into a plane of unconscious experience. When he finally slows down, the tunnel closes and darkness sets in. After a few moments it lifts. He is in a hall that leads to a living room partitioned by stylish dividers and lined with red upholstered benches that remind him of the 1930s. A young man is sitting at a table at one end of the room. He beckons the artist to approach.

. . .

The artist had only been keeping a dream diary for a few days when it occurred to him that it would provide good raw material for a new piece of work. He decided to continue to write down his dreams each day but would need to effect a formal change. He would write the dreams as a series of letters, much like an epistolary novel, and the recipient of the letters would be the gallery that represents him.

The following is an excerpt from his notes on the piece which were later included as an appendix to the work's first printed edition:

> I anticipate that our correspondence will be somewhat one-sided, with my letters rarely receiving a response. Thus the exchange may take on the flavor of unrequited love. But the project's purpose is a critical one: by handing over my dreams – fantasies, imaginings, my most personal experiences – to the gallery I will explicitly perform the alienated economic and social condition of the artist who prostitutes his creativity on the market... I might even suggest that the gallery assistants make drawings based on the dreams so that the conversion of the raw material of my intuitions into commodities will be complete.

. . .

Dear _____,

In my dream, the gallery has planned another show at the same time as mine and I've effectively been strong-armed out of my position. The other artist, a woman I know, has made a wooden thatched house and she's going to be doing something with it. 'Why don't you do hers another time?' I ask the gallerist. 'Don't worry about it,' they say, 'You guys should hang out, go for coffee together.'

I'm in the bathroom later and, as I use the toilet paper, I realise that a deeper layer in the roll is concealing a wad of shit. As the layers unfold I get closer and closer to the shit concealed there, and then finally the toilet paper becomes unusable. It's revolting.

Like some Mafia threat, the shit is a way of telling me to get out while the going is good. I hear from over in the next stall, 'Is there shit in your roll of toilet paper too?' A colleague steps out and says that he's being punished as well and, of course, he gets it much worse because he's old.

Best,

The artist consults with the gallery first to make sure that they're willing to support the piece and then sends the letter. A response arrives two days later.

Dear _____,

Thanks for your letter. We're not that sure how you would like us to write in response, but we hope that the project turns out well.

Best wishes,

. . .

Dear _____,

In my dream last night, I open my emails and the spot that I click on the screen erodes away. Behind it is an image of the street outside my house and then, as if in a film, the next scene starts with me in the street. I'm with a few friends and we are walking. A dark blue truck with the word JUGGERNAUT printed on it drives along beside us. As it turns a corner, I point out to my friends that it's expanding and that we should move

away. Its back end is unfolding so that it grows higher and wider, then it gets longer, coming uncomfortably close to us. The truck is no longer turning away but begins to drive in our direction. We very narrowly manage to get out of its way. It threatens to crush us again when it folds out a broad and dangerous contraption that looks like a peacock's tail. It unfurls rapidly, nearly trapping me under it.

Once we're at a safe distance from the truck, we're curious about who is in it so we speed as if disembodied to catch up and be in line with its cab. Inside are four art collectors, drinking and enjoying themselves and we realise that they're celebrating some auction or deal that went well.

The next scene cuts to a whorehouse filled with impoverished Latino women – one woman stands apart with all the others grouped around her. The same collectors have arrived to celebrate. When they approach, the women all begin dancing, rocking their pelvises back and forth to the music. Their lower bodies move in a series of rapid poses as though the film had just sped up. The men stand around watching as the main woman makes coy and provocative faces.

Then I hear a banging from inside the container of the truck. It is a group of illegal laborers being transported to their jobs somewhere in the hinterlands outside the city. I worry for them stuck inside that container.

If you're wondering what this has to do with anything, perhaps you should leave it to your assistants to interpret the dream in whatever medium they see fit.

Yours,

. . .

After several more of these communications, the artist comes to a grave realisation, but he is not very clear about what it means.

Dear _____,

I am in a very wealthy, newly corporate-sponsored Kunstverein (with a Kunsthalle atmosphere) where my work will be exhibited in several months, looking at the show they have on. The work is a full-sized representation of an actual city street somewhere else in Europe. At one end stands a beautiful art-deco building whose charm had provided the original stimulus for recreating the street. The artist wanted to remake not just the building but also its context, including all the people who live in the area or frequent that street, down to the minutest detail. As an afterthought, the artist began to consider the politics of the situation. The people, if they were really to be like the people that exist around the building, would have to live their lives freely. The

artist had read that all politics are a performance of sorts and she had misunderstood this to mean that she could literally stage a politics.

So a group of people were paid enough to spend all their time submersed in literature about their social condition and then have interactions based on what they learnt about themselves. In fact the artist, inspired by the splendor of her art-deco building, thought that this would be the perfect setting for a real utopian politics to come to fruition. 'We have no needs here, everything is provided for us, you just have to demand it!' she told them. The Kunstverein almost became a life-sized version of the computer game *Sim City* with every detail taken into account. But, nothing particularly unpredictable came about, despite the artist's continuous attempts to stir-up political tensions or compel the participants to some decisive act where they would try to improve their condition. And what did she expect? The people needed their salaries too badly to step outside the prescribed limits of their character.

Best wishes,

.　　.　　.

The artist reflected and wondered whether he's not like the artist in his last dream. It occurred to him that his project was replaying a familiar epistemological binary: critical faculties putting the passive material of experience to work, a subjugation of his dreams by his rational thought. In trying to draw attention to the instrumentalisation of the artist's creative and intuitive capacities he had set up a relation of supremacy whereby his own critical meta-discourse would reveal a higher truth about a supposedly lower form of discourse: his dreams. He now understood that he has simply repeated the age-old dilemma of intellectuals and vanguardists who try to educate the people in order to help them improve their lot. He is reproducing an order that presupposes them un-informed or inferior. He thought of Brecht, who for better or for worse, had wanted to educate his audience. But then he wondered, 'aren't my dreams start-ing to educate me?'

From then on, the artist, having learned this new lesson possibly too well, tried to devise a new performative action that would go beyond the enactment of art commodity exchange in his previous attempt. He worked fervently on this next line of attack, unsure what it would be, using his dreams as a guide instead of manoeuvring them for his own ends. Reading over his letters, he began to see the dreams as another kind of criticality that could challenge the presupposi-tions he had previously imposed on the world. He would redress the inequality in his original project by acknowledging, through his work, that these two types

of thought – the rational and the intuitive – were radically different but neither better than the other.

· · ·

Dear _____,

I dreamt that a recently bought house was being renovated and that the new occupants wanted to leave traces of the previous décor intact to remind them that the house had prior owners. In one of those quick conversions of dream logic, this became a new trend in the art galleries: for a few seasons now all the shows in Chelsea included elements from previous exhibitions – a bit of the last wall color here, the traces of a built wall there – so that an accretion of details from previous shows would inform the viewer of the gallery's recent history. When the erasure of what went before is ever more imperative in order to continue the drive into the future, it becomes essential to fetishise the signs of having had a past. So what ostensibly presents itself as a materialist treatment of history is actually a revamping strategy blinkered to the fact that it's far too late.

Best,

· · ·

Dear _____,

In last night's dream I saw a map that charted all the art practices in the world as well as all the relations between them. The map was morphing as I watched it and I noticed that many of the artists were consolidating into groups. When I asked someone next to me why this was, she responded: 'The art world continually proliferates and diversifies new practices. In an ever-expanding field of production one strategy that artists have adopted is to form super-identities in the form of collectives. The political connotations and social commitments that had inhered in such a strategy have, for the most part, evaporated, leaving behind a few residual signs. Many factors play into this surge for consolidation. One in particular is that combining one's resources as artists, much like both the collectivisation of labor or the intensification of accumulation effected by capitalist concentration of production, gives logistical and strategic advantage.'

While the woman was speaking the map became a series of photo stills from performances by art collectives. One was a large group of artists performing a mass

choreography of sorts reminiscent of Soviet rallies. The next showed a collective re-enacting an anti-capitalist demonstration of the year before. Many people from outside the collective joined in and it eventually resulted in a stand-off with the police. As the images went on, it became clear that the police, realising the protest was fake, had begun to use the rally (either with or without the art collective knowing it) as a war game to practice urban protest-control. The mock-demonstration proved so easy to contain that the police began to covertly support their future staging since these demonstrations conceived of as theatrics tended to delimit themselves and also to pre-empt more unruly forms of public dissent.

Best,

. . .

The artist tried to reformulate the project in numerous ways, but ultimately, each failed for the same reason. The equality (in difference) that he sought between dreams and rational thought was ineffable and elusive, and simply expressing the alterity of dreams seemed always to lead him to mystify or romanticise them.

Meanwhile, his dreams had become better critics of the art establishment than himself. They were continually generating new critiques at precisely the moment when he wanted to believe in their sovereign difference from critical thought. The artist presumed that he was alienating his oneiric inner life by turning his dreams into creative raw material for the gallery system. Instead he finds that the art world has in fact become the raw material for his dreams and that his inner life is relentlessly focused outside.

He started to think that maybe there was good reason why no artist would touch the topic of dreams with a ten-foot pole.

At this point, after many weeks of not hearing anything, the artist receives a response:

Dear _____,

We've been reading all the letters and notes you've sent us, paying close attention to the concerns that you've had about the project. Regarding one of your remarks, we think that the best way to dissolve any ordering principle in your work before it can become hierarchical is to not make any objects like texts or drawings, but to turn the same ideas into events or performances instead. That's why we've decided that rather than executing your dream diaries as drawings we would like to have them staged by actors (or non-actors). How would you feel about this?

Best,

Confused and dismayed, the artist hopes for a dream that will bring an answer, but all he is given are nightmares:

Dear _____,

For several nights in a row I've been haunted by dreams of a constant revolution that is international but not fought on class lines. It is announced publicly that, since politics have always operated through a set of theatrical and artificial roles and scenarios, all politics are now to be considered as aesthetics and theatre. And if politics are aesthetics then revolution will amount to a battle of spectacles and styles. Aesthetics has its own ways and means of conducting politics and they will be transposed over what's left of the post-political public sphere.

All across the art world, barricades are erected from the meaningless rubble of weekend events. A new model was already developed here: one-off context-specific performances, exhibitions lasting only a matter of hours, fostered by an art economy of spontaneous and improvisational production and strategising. The revolution incessantly produces heroes and I find that I am one of them as my practice has always performed a theatrics of revolt. The art economy is propelled ever forward into increased productivity where the new has always already been replaced, where nothing ever settles or is fully given form.

The revolution isn't just riddled with profit opportunities, *it is one* since a glut of as-of-yet undervalued art works are available to the market at any given moment. In addition, it is assured that at a multitude of unfixed and unpredictable turns each work's value can appreciate immensely. The revolution doesn't dissolve the art world for good but rather over-inflates it until it is finally instated as the meta-economy, overshadowing the temperamental market for stocks and derivatives.

Nothing, no consensus ever solidifies and adheres into a fixed order. No paradigm shift is possible in society at large. Instead we have a paradigm of shifts that keeps everything in check, maintaining and refining the current economic order; advanced capitalism at its most pure.

. . .

This text was written in 2006 as a response of sorts to Jacques Rancière's text 'The Emancipated Spectator' and it originally appeared, along with that piece by Rancière, in issue #8 of New York-based publication *Continuous Project*, published by CNEAI, Paris, 2006.

Politics must be invented

Jan Verwoert

WHERE DO POLITICS start? How do you start to be political? When do things start to become political? Carl Schmitt had a clear answer to these questions. He argued that politics begin when you start to distinguish between friends and enemies. To make this distinction is a powerful symbolic act. It is the act of naming friends and denouncing enemies. This act cuts right through the fabric of social life. The political splits society and it emerges out of this split. The political is inaugurated through a cut. It takes somehow to perform this cut, a performer with the power to address the public and make it believe that those whom he names as friends and enemies are really whom he has declared them to be. Politics are therefore born in a moment that is as mythical as it is theatrical. You have to make a scene to politicise social life. And it takes a big scene to make a whole society believe in your distinction between friends and enemies. To put an entire society under its spell, the inaugural act of politics must be more than just a delicate theatrical scene. It must become a powerful spectacle. This is America today. And it was Nuremburg seventy years ago. Albert Speer knew how to make a big scene to politicise the people. Send search-lights up into the sky. Enthral your audience with the devastating beauty of light and the powerful promise that the future will unite the people as friends against a shared enemy. Politics needs a master of ceremony, a prophet, a priest, a herald who steps into the arena of the public and seizes the microphone to have his voice amplified by a multitude of loudspeakers, transmitters and receivers, when he points his finger at those who he exposes as enemies and opens his arms wide to embrace those who he calls friends. Do we search for someone to perform this trick for us today? Or do we turn away in disgust and disbelief, driven by the conviction and hope to never be fooled again?

Where does this leave us as artists, intellectuals and producers of culture? The good news is: The inherent theatricality of politics puts us in a position of power. We don't have to *get into* politics. We are always already right in the midst of it. As public performers who address and assemble an audience by staging works, debates or events we create the social space of culture and, by polarising public opinion, sometimes even succeed in dividing this culture into friends and enemies. Politicians and cultural producers are basically in the same trade. This is why Plato wanted to have artists expelled from his ideal Republic. He feared that they had too much power to influence public opinion or would maybe even give the game away by making it all too clear that politics originates in theatre. So there are good reasons for taking ourselves much more seriously than, (being modest and self-critical people), we usually dare to do. Politics must be invented. This is how it comes into being. And since inventing

things is what we do all the time we might as well invent some politics while we are at it.

The bad news is, however, that compared to the power of contemporary mass media, the potential of art to make a scene that would politicise the crowd is minute and negligible. Let's not kid ourselves. Artists and intellectuals can never seriously compete with the big show of war and peace, wealth and poverty that the government, the corporations and the media put on to thrill the people. Art and intellectual discourse just demand too much time and dedication. They seldom offer great excitements and come across as too fanciful, fragile and complicated to have any strong effect on a public that has, by now, been raised on much stronger stuff. At the beginning of the last century, one or the other bourgeois might have done art the service to be genuinely shocked by it. These days, western capitalism employs highly-skilled professionals to develop best-selling shocks and thrills on big budgets. Compared to the magic of the media machine, the showmanship of artists and intellectuals must rate as relatively meagre. Instead of the spectacular moments captivating the audiences of big arenas, our appearances in the limelight will always be closer to the little tricks performed by a prancing pony in a circus matinee or the faint whiff of glamour conjured up by a wedding party singer crooning to the automated arpeggios of a Casio electric piano.

Yet, people can be genuinely affected by weddings and matinee performances. So maybe the size of production budgets doesn't matter when it comes to the potential existential impact of art and culture? Entire lives have been changed by just one book, one painting, one record (or its cover) or a few pages in a fashion magazine. This is as much a reason for hope as a cause for moral concern. Because for any individual whose mind and body is set free from the imaginary constraints of the social status quo by a piece of art, literature, music or philosophy, there is at least one impressible adolescent (these days it rather seems to be dozens) converted to the delusions of some reactionary radicalism. For any free soul there will always be a Varg Vikernes on the opposite side of the political spectrum preaching hate with the very same passion that drives those who propagate art, love and criticality. The energies that an intimate encounter with a cultural artefact may release can propel people in all kinds of unpredictable directions. Since 1790, when a cobbler who had hanged himself in Halle was found to have carried a copy of Goethe's *The Sorrows of Young Werther* in his pocket, thus copying the fate of his literary hero by killing himself, the pedagogues of the modern nation have been worried that an overdose of culture could lead people astray.

Guided by moral panic the national pedagogues from then on put anything from pornography and computer games to jazz, expressionism and other forms of art they deemed 'degenerate' on the index. Thanks to these pedagogues and censors this index has now for centuries been a reliable source of essential reading, viewing and listening material for any non-conformist artist and

intellectual. Yet, beyond the thrills and chills of indulging in radical chic the confrontation with the stale morality of the national pedagogues does in fact and in a most pressing way again raise *the question of the political*: When we reject the false moral standards of the censors and national pedagogues as just another ideology designed to preserve the social status quo—and when we do so because we believe that art and culture can only be free and have the existential impact of liberating our minds and bodies if it can unfold without being inhibited by censorship and false moralism—how do we then *distinguish between friends and enemies* in the (sub)cultures we inhabit together with all those who dedicate their lives to freely living out the inspirations and obsessions they have developed within these cultures. How can I, for instance, potentially (and figuratively in a political sense) call an artist a friend who, high on a black metal trash mythology, invents larger than life scenarios of carnevalesque transgression, while I can safely say that an ex-metalhead spouting occultist white suprematist Neo-Nazi gibberish from inside his prison cell just ain't no friend of mine? How can I love Laibach and at the same time have qualms about Rammstein? How can I study Aleister Crowley with pleasure and not be a Satanist or read de Sade with joy and not be a Sadist? Or in more general terms: How can we reinvent the distinctions of the political in a culture beyond good and evil?

When morals fail, ethics might help to provide the grounds for this political distinction in art. Morals are the set of values that a society and those who rule it declare to be binding for all that live in that society. Ethics, on the contrary, are about the attitude to life that is immanent to—and manifests itself through—the particular way people live their lives. Ethics are a matter of practice. Your ethical principles reveal themselves in the particular style of how you go about what you do. In art and intellectual discourse, style is ethos and ethos style. This is also why in art and intellectual discourse the intrinsic theatricality of ethics is played out and thrown into relief. We all wear our ethics on our sleeves when we step out into the public sphere by exhibiting work or presenting our ideas through writing or talking. Ethics are immanent to the pose you take, the tone of your voice and the humour that may come out in the moment when you expose yourself, your work and your views to the public. This scene of making your position public can become the scene of politics when you choose to divide those whom you address into friends and enemies. But even before it is decided whether this scene inaugurates politics, it is always already the scene of ethics. Even before you begin to address the people, the way you move and dress when you step onto the stage and behind the microphone is an act that counts in ethical terms.

In these ethical terms it makes all the difference how you choose to make your appearance, figuratively speaking as well as in the literal sense. Do you walk with measured steps and keep your calm and composure when the eyes of the public are on you? Or do you assert your position forcefully by charging up onto the stage with a resolute stride? Or maybe you choose to cast your eyes

down with modesty when you address the people and only look up from time to time to seek a momentary eye contact with a random member of the audience? Depending on the situation you perform in, you might choose to do it differently. So ethics depends as much on principles and style as on a responsiveness and alertness to the requirements of a particular occasion. Friendships and love can begin on the same occasions on which long lasting animosities and feelings of resentment can equally be caused. Whether you feel drawn towards someone and recognise him or her as a potential or prospective friend or lover, or whether, quite the on the contrary, you feel repulsed and insulted by someone who from the moment when he or she opens their mouth already speaks with the tongue of the enemy, all of this depends on the style in which this person addresses him or herself to you through body language, through art, through fashion, taste or words. It is through the immanent theatricality of how people present themselves to each other that the social world always divides itself into circles of friends, clans, spiritual families or groups. So the origin of politics is already implicated in the sympathies or antipathies that arise out of the response to the immanent ethics of another person's way of being.

Unfortunately, we are often deeply misguided and horribly wrong about the motives that make us sympathise with some people and reject others. Some if not all of the greatest catastrophes in history in fact started with some prophet, leader or Führer directing our sympathies towards some (our own) people and mobilising our resentment against others—maybe even against those who for years had been our neighbours and towards whom, even though they had a different ethnic origin or religion, we felt, if not sympathy than at least a kind of indifference that allowed us to live with them for generations. Articulated politics force ethical affiliations out into the open and thereby eradicate all the latent ambiguities and complexities that inevitably arise from the way sympathies change over time like any other moods. In the moment when the choice between friends and enemies is put before you, you cannot remain undecided anymore. You must take a stand. When the president asks you 'Are you for us or against us' you must not answer: 'In principle yes but still x is a neighbour, not my enemy although x is a Muslim/Christian/Jew etc.' At the moment when the political splits the social sphere there is no more space for latent sympathies or ambiguous feelings. All must be made clear once and for all. Yet conversely, this also means that affiliations based on sympathies with the ethos of others precede the political and can never be more than proto-political. It is quite simply because they can remain latent and they can change over time. Ethics allow us to learn about each other. Politics doesn't. Once the enemy is named, war is declared and battle come down, there is no turning back. Everything will burn.

The urge to learn about the ethics of others, however, is central to a love for art and intellectual discourse. What do we learn then from this love? The lesson of art and intellectual discourse is contradictory: On the one hand we learn to trust our intuitions and taste the more we see and get to know about

art and thinking. We become very good at grasping within seconds how things will develop when they start in a particular way. We know how to spot a soul-mate, how to pick a fight with a worthy opponent and how to keep out of the way of people and works that only annoy. On the other hand we learn through mistakes that we can be utterly wrong about our intuitive choices and there-fore have to be very careful not to reject a work or thought prematurely. True criticality in (the production as well as reception of) art then only emerges out of taking both these lessons to heart: Learn to trust that anyone with an open mind will recognise the ethics and politics of your practice on the basis of the intuitions and attitude to life you may share (so don't push to hard, there is no need to become too pedagogical, people will know what it means if they know what you mean). But also learn to mistrust anyone, including yourself, when they try to make you believe that art, life or ideas could be easily understood. In art the truth is always hidden in plain sight. So you must come to know how to take things at face value and at the same time never judge a book by its cover. With art and ideas there is no truth without passion. But passion reveals truth as much as it conceals it. So to be able to see the truth that lies in the passion for art and ideas you must add to your love an attentiveness for the blind spots in perception that your passions will inevitably produce. To learn the lesson of the ethics of art and ideas therefore means to develop a sense of *simultaneous unconditional trust and mistrust* in your own principles of sympathy and resent-ment, affiliation and animosity, identification and hostility.

But can this lesson ever prepare you for politics? Or will a developed sense of simultaneous trust and mistrust effectively prevent you from ever engaging with politics in the immediate and unambiguous way that the brute distinction between friends and enemies demands? Can anyone who is guided as much by passion as by scepticism (and a passion for scepticism) readily step out into the public and declare without scruples, second thoughts or reservations that some shall be friends and others shall be enemies, now and forever? Does not the initiation into the lasting love for the intricate immanent ethics of art and ideas make it impossible for anyone to perform the brute act of making a scene in public to split society and unleash the power of the political? I believe it does. So the question is: If taking the ethics of art and ideas seriously precludes us from ever performing the artless and thoughtless act of naming friends and en-emies, does this then mean the end of politics in art? Or can a different politics be invented out of the ethics of art, a politics that would not be forced into being by the powerful division of the social sphere?

If so what would this politics be? Wouldn't it be fantastic if there could be such a politics? A fantastic politics based on unconditional love and trust for all that is beautiful and free and unconditional mistrust for all the power, corruption and lies? Would you trust me if I told you now that I believe this politics born from the ethics of art and ideas is possible and real in the communion of our emotions and ideas through art? Or would you detect a particular tone in the

sound of my voice and style of writing as I tell you this? A particular messianic tone which will alert you to the fact that I am beginning to preach? Can you ever trust someone who ends an argument by beginning to preach? It's up to you now to make this decision. Contrary to the way in which those in power stage the political scene to forcefully and irreversibly divide people into friends and enemies, art and intellectual discourse leave it up to their recipients to privately, even anonymously, make or revoke their choice for or against the propositions they make. So if you choose not to trust me now when I tell you that a fantastic politics based on love and scepticism is possible, maybe you will trust me later? Maybe after you have seen the art in this show? But honestly, is not the circumstance that in the end it will now be your choice, the best proof for the fact that in the space of ideas we are sharing in this second, as you read this, power can never be imposed even though a crucial choice must be made — and that in this anonymous but intimate encounter with an idea a fantastic politics is therefore already in full effect? Trust me, it is. Well, alright, you decide.

First published in *Fantastic Politics: Art in Times of Crisis* (Exhibition Catalogue, National Museum of Art, Oslo, Norway, 2006) by Andrea Kroksnes, Sune Nordgren, Anne Karin Jortveit, Jan Verwoert

Faith Wilding responds to Kate Davis' questions

Kate: In 1972, you performed and exhibited in the seminal Womanhouse, a woman-only exhibition initiated by Judy Chicago and Miriam Schapiro in a house in Los Angeles. Reacting to a lack of opportunities for female artists at that time, Womanhouse provided an essential and visible forum for feminist art activity, just as the artist-run space Transmission Gallery was driven into being in 1983 by a desperate need for exhibition spaces and opportunities for young artists in Glasgow. In relation to feminist art activity, how do you feel the role of the artist-led initiative has changed since the 1970s?

Faith: A big question that needs a book-length answer. But let me come at it in another way. Womanhouse actually came about in the way it did partly because there had been a major earthquake in Los Angeles just before school started in the new California Institute of the Arts campus in Valencia, and no classes could be held in the building for the first 2 months of the semester. Judy Chicago and 6 students (including myself as graduate assistant) had come from Fresno, California to start a Feminist Art Program at CalArts in collaboration with Miriam Schapiro and 14 other students. We decided to begin with a collaborative project, and it was then suggested by Paula Harper, our art historian, that we should do a project about domesticity and women's experiences in the house. And then it was just a small leap to the idea of making the first feminist site-specific environment (installation) on an ordinary street in Los Angeles. You are right though, to point out that part of the impulse of Womanhouse was the strong move in those early 70s days of feminists and other minoritarian groups challenging the entire art system, its spaces, its exclusivity, its white/male/genius-centered assumptions and structures, and its monopoly of what counts as art.

Eventually, for feminist art, this engendered a host of alternative and women artist-run spaces, publications, courses, collaborations, etc. which in Los Angeles culminated in the Woman's Building and the feminist art collective Double XX. I think the artist-run initiatives are still strong in certain ways, but often they no longer really feel like an alternative. Often it is more like a specific group of artists who already have high profiles and are banding together to make their own scene and show work they maybe can't show in museums and galleries. And there's nothing wrong with that really. There are still several women only galleries in New York, like AIR. I think the fact that so many artists are working collaboratively and working in non-art venues such as clubs, the street, and many other spaces has changed the scene quite a bit.

Kate: Have these changes affected the nature of your own artwork? And if so, how?

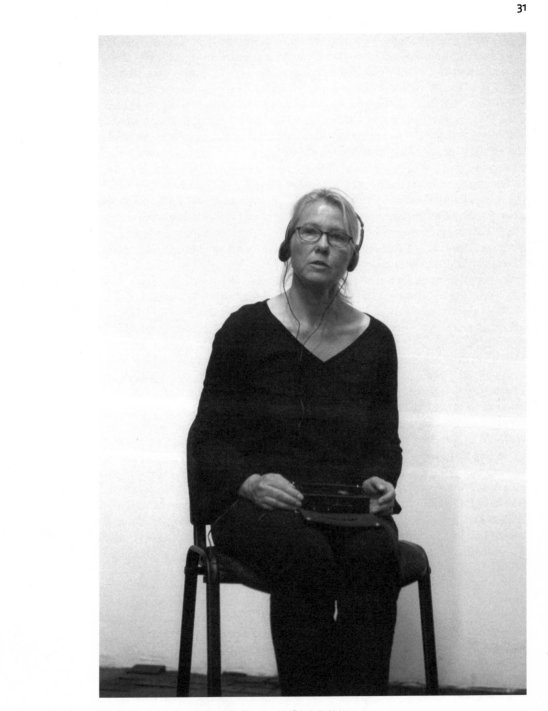

Faith Wilding, Centre d'art contemporain, Geneva, 2007. © Isabelle Meister

Faith: Well, the 'art-scene' in which we all operate has changed fairly drastically several times since I first started out as an artist in the early 70s. I was never able to find a gallery or to become a gallery artist for more than about a year or so. I usually showed in museums, public art venues, university galleries, alternative spaces, etc. I worked in various ways with several artist groups and in fact throughout the 90s I collaborated on performative and political projects with collectives in Europe and the US. An example of such a project would be the 10-day Cyberfeminist International residency in the Hybrid Workspace I was involved in with the Old Boys Network at Documenta X. Since 1998, I've virtually stopped making work individually since I co-founded, and now work with, the cyberfeminist collective subRosa (www.cyberfeminism.net). We produce a great variety of projects: site specific performances, performative installations, publications, lectures, workshops, interventions, etc. We've performed in museums, at electronic arts festivals, in contemporary art spaces, in colleges and universities, and other spaces too.

Strangely, in 2007, I am suddenly being invited to show my 1970s early feminist work in exhibitions around the world. This is due mainly to the currently revived interest in the feminist art movement (of which I was an active part) being showcased in such big exhibitions as *WACK! Art and the Feminist Revolution*.

Kate: Early next month at PS1 in New York, you will be performing your re-do of the *Waiting* piece, which you originally performed at Womanhouse in 1972. In contrast to the artist-led initiative what possibilities or limitations does an international institutional platform offer your practice?

Faith: Well, there are all kinds of practical support of course such as publicity, providing the space, managing the audience, reviews, etc. Which is nice not to have to think about. And most institutions have been very hospitable and respectful. It has been an ambivalent experience though, seeing the work that was first done in the context of a feminist collaboration now being exhibited as 'named art' in big art institutions and contextualised in different ways. And to realise that one is recognised as an art personality. That is unsettling in terms of a loss of direct contact with an audience—and not knowing how one's influence is actually being processed by younger artists.

In Three Guineas, Virginia Woolf cautioned women to remain outsiders to this system of official recognition and reward, as she thought it would keep us more honest and focused. I tend to agree. However, I must say that acknowledgment feels great when it comes in the form of someone like yourself taking up the challenge in *Waiting in 1972* and asking the questions again in 2007. It gave me such a thrill when a student of mine called my attention to your performance/installation at Art Basel 07. I myself have always fed off the work, writing and lives of other women artists, writers, theorists, political and social activists, and I think this is how we can keep bringing their ideas and their actions into our

present work, and into the public arena as a living, inspiring, and absolutely relevant history.

I am inspired now by the many feminist theorists, art historians, art students, and younger women collaborators who are interrogating my work from the past, and helping me to sort out what I can do now. It really allows me to be effective in my time. So I thank you very much and hope that we may someday actually collaborate face to face.

Kate Davis responds to Faith Wilding's questions

Faith: I've noticed that many of your works seem to be inspired by, and cite, other women and/or women artists. For example, you cite one of my great inspirations Käthe Kollwitz: *Ich will wirken in meiner Zeit*. I'm curious as to how, when, and why you adopted this strategy of re-incorporation and how does it help you to think newly about feminism and women-in-the-world?

Kate: When I graduated from Art School, I had problems justifying why I should add to the plethora of artwork being generated, and initially channeled my passion for art into research and working in galleries or on artist-led projects. Of course, thinking about and assisting with other people's work made me desperate to make my own! But that need to continually question my role as an artist today, is what now drives my visual practice. To grapple towards Käthe Kollwitz's notion of 'functioning in the present time', I feel a need to reconsider and attempt to move on from a past. The question is how I can use my interpretation of certain works from art history to say something critical in the present? In the last few years I have been increasingly drawn to re-investigating seminal works by female artists (such as Sylvia Plath, Käthe Kollwitz, Barbara Kruger, yourself and Joan Jonas) in part, to try and challenge the relevance today of a feminist art activity. Born in the late 70s and studying in the 90s I have been fortunate to benefit from certain possibilities and opportunities for female artists which have only arisen out of a not so distant feminist history. Accepting the situation for artists and women is very different today, only seems to make it more imperative to return to those fundamental concerns and re-evaluate what feminist and art activity needs to and can be today. So for me in 2008, feminism is as you described Faith, about bringing that living, inspiring and absolutely relevant history into a public arena and using any appropriate means to extend that dialogue.

Faith: I am wondering now how you relate to the philosophies of feminism in your own life, and what you think are the new challenges facing young women artists today, both personally and politically?

Kate: Aside from questioning the philosophies of feminism through visual means, I attempt, as a female artist working today, to be as active and engaged as I can with a local and international art dialogue and am extremely interested in and supportive of a younger generation of artists, whether female or not. Recently, I've been thinking about Yvonne Rainer's statement 'I want everything I make to reflect my whole life' and whilst I believe the personal is still a fertile and important terrain for creativity, I want to question the use of self in my own practice.

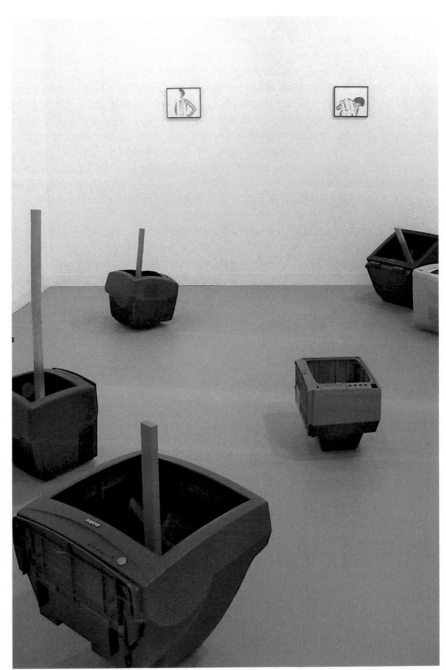

Kate Davis, installation view, 'Waiting in 1972; What about 2007', solo statement with Sorcha Dallas, Art Basel 2007
Courtesy Sorcha Dallas, Glasgow

From my limited experience, I think the most critical challenge facing young women artists today is how to negotiate and operate critically within, as you said, a very different art world, in which it is possible to live and work as artists. To receive international and institutional support can be of enormous benefit both personally and professionally, and crucially enable a practice to be furthered. Inevitably, this isn't always the case for female or male artists (and even when it is, it isn't necessarily sustained) but when that platform is presented I think the question is how to work against the limitations of that context and generate debate that needs to be furthered today. The Virginia Woolf caution you mention is so interesting and whilst I also agree in part, I propose that female artists need to use a system of official recognition to their own means (just as a large-scale exhibition like *WACK! Art and the Feminist Revolution* can help re-contextulise and re-evaluate feminist art activity on a global level). The accessibility to that information and history, which allows a student at Glasgow School of Art to watch documentation of a performance made in Los Angeles in the 1970s, I would hope is empowering and could generate a new body of feminist art activity that is relevant to the present.

Faith: My last question is about what you see as the direction of (feminist) art and performance in the next decade or so? There seems to be such a strong impetus now to work in groups and collaboratively, I'm wondering how you feel about that?

Kate: In 2006 I was involved in an exhibition that was part of a larger ongoing discussion with artists, both of which were titled *If I can't dance, I don't want to be part of your revolution*. Initiated in 2005 by Frederique Bergholtz, Tanja Elstgeest and Annie Fletcher as a rolling curatorial project focusing on performative practices in the visual arts, it expanded to explore feminist legacies and potentials in contemporary art through exhibitions, symposiums, events, writings and a reading group. Rather than concentrating on any singular outcome, the emphasis was on furthering debate in a critical and celebratory manner. The idea of art making whether feminist, performative or not, being thoughtfully sustained and supported as a long term enquiry, with exhibitions existing only as a transient part of that wider dialogue, isn't a new idea (though I'm not sure how often it is seriously pursued) but as a practitioner I feel it is increasingly essential. If feminist art activity is to follow Woolf's notion of the outsider (or the insider with outsider motivations) then that serious enquiry surely needs to be uprooted, challenged and accordingly maintained in an effort not to be irrelevant, ignorant or feminist for the sake of it. I would hope that over the next decade we might see more of that commitment from artists, writers and curators, so that even when a practice is a solitary means of production, the reception and repercussions beyond that become a considered collective act.

Personally I collaborate with other artists in terms of fabricating work, but I can only seem to develop ideas on my own. I don't think I could, should or want (yet!) to subject others to the vague and murky terrain where thoughts need to be sifted before they can eventuate as anything tangible; that non-verbal process can be so valuable too. However, I do have great respect for many collaborative practices and find working with others on exhibitions, events, writing and other projects stimulating and nourishing just as this conversation has already had such an impact on my thinking. I hope the next decade (and the wonders of e-mail!) provide many opportunities for further conversations about work past and present, from one country to another. Thank you so much for this dialogue Faith.

Inventory 22.02.08

Babak Ghazi

Agency
Andy Warhol's Diaries
Andy Warhol in his Own Words, see Colour; see also Perspex
Appropriate, see Swastika
Beuys, Joseph
Bowie, David, see Shapeshifter
Choose1.jpg, see also Injunctions; see also Ponytail
Colour, e.g. Pink, e.g. Yellow, e.g. Orange
Consciousness
Control
Copyright, see Prince; see also Control
Creative, see Swastika; see also Injunctions
Cut-out, see Pose
Display, see Seeing Itself
Entrepreneur, see Gates, Bill; see also Agency
Event, see Slogans
Ferry, Bryan, see System
Gates, Bill, see Bad; see also Good; see Also
Glamour
Goude, Jean-Paul, see One Man Show
Hamnett, Katherine, see T-shirts; see also Consciousness
'Heroes', see Collaboration
How-to-do-it, see The Joy of Sex; see also Model
i-D, see The Face; see also Injunctions
Injunctions, e.g. Choose Life, e.g. Do-it-yourself
Jones, Grace, see Goude, Jean-Paul
Jpegs, see Pixels
Labour, see Work in Progress; see also Labour isn't Working
Left-wing, see Material
Limits, see Economics; see also Meaning
Look, see Injunctions; see also Style; see also Display
Love Symbol, see Unpronounceable; see also Self-definition
Mapplethorpe, see Rotation; see also Undecidable; see also Liberation
Material, see Inventory
Meaning
Mirror
Model, see Prince; see also Straight Up; see also System
Nazi guard phrase, e.g. Spandau Ballet, e.g. Joy Division; see also New Order

Not Yet Night, see Event
Objects, see Pose
Options, see Material; see also Intuition; see also Model
Pantheism, see Everything
Perspex, see Look
Photocopy, see Look; see also Claim
Pictures, see Model; see also Agency; see also Material
Place, see Pose
Pose, see Place
Prince, see The Artist Formerly Known As Prince; see also Unpronounceable
Public, see You and Me; see also T-Shirts
Questions, see System
Self-definition, see Press Release
Self-Portrait
Slogans, see Curl
Spandau Ballet, see Liberty Leading the People; see also Appropriate
S. Strange, see Strange, Steve
Strange, Steve, see Mirror; hear 'Would you let yourself in?'
Straight Up
Style
Swastika, see Creative Review
System, e.g. Dandyism, e.g. Pantheism
This is a Record Cover, see Consciousness
T-Shirts, e.g. Choose Life, e.g. Me; see Protect Me from What I Want
Undecidable, See Glamour; see also Event; see also Colour
Unpronounceable, see Love Symbol
Untitled, see Cindy Sherman
Victim, see Narcissism
Work in Progress, see Entrepreneur
You and Me, see Not-yet

Exhibitions & Projects

ERNST CARAMELLE
at **Mary Mary**

Commissioned by Mary Mary in association with the Gi Festival 2008
Image: Ernst Caramelle, *wallpaintstudy*, 2007 (watercolour on paper, 31 × 24cm)
Courtesy the artist & Mary Mary, Glasgow

▸ www.marymarygallery.co.uk

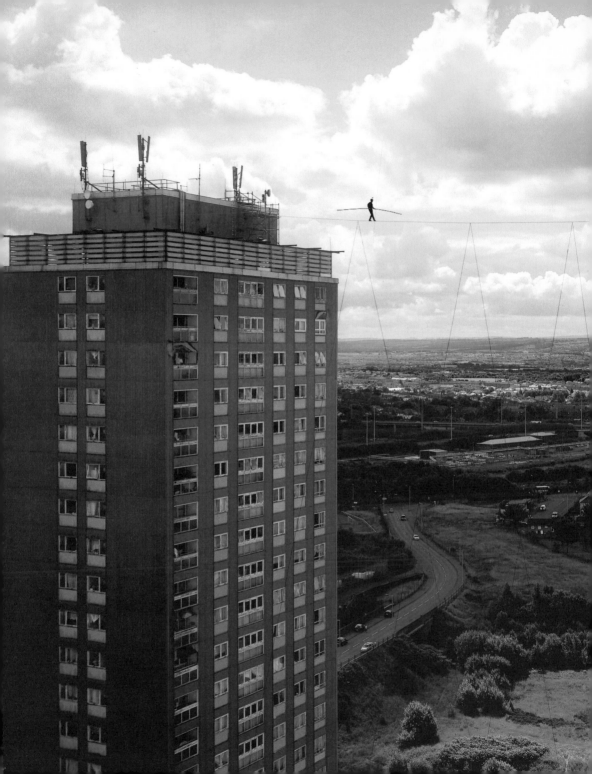

'HIGH WIRE' – CATHERINE YASS
at CCA

High Wire is commissioned and produced by Artangel and the Gi Festival 2008
Supported by the National Lottery through the Scottish Arts Council, The Henry Moore
Foundation, Arts Council England, Institut Français and CCA
Image courtesy the artist

► www.artangel.org.uk · www.high-wire.org.uk

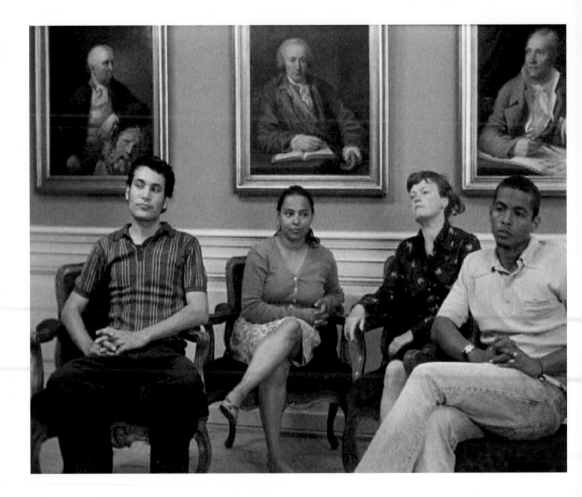

'CAST SOME LIGHT'
at CCA / GFT / www.castsomelight.net

Anna Bokström, Katie Davies, Shahram Entekhabi, Johanna Fjaestad, Freee, Tamar Guimarães & Nanna Debois Buhl, Narve Hovdenakk, Henrik Lund Jørgensen, Jesper Just, Shakuntala Kulkarni, Jenni Leskinen, Sladjan Nedeljkovic, Jon E Nyholm, Jette Hye Jin Mortensen, Tova Mozard, Asaf Yosef Shani, Cheryl Sourkes, Stina Wirfelt

Commissioned by the Gi Festival 2008
Supported by the Nordic Culture Fund and Kunstrådet, Danish Arts Council
Image: Tamar Guimarães & Nanna Debois Buhl, *The Most Beautiful Place* (video still)
Courtesy the artists

▶ www.castsomelight.net

THE COMMON GUILD presents
THE RODNEY GRAHAM BAND LIVE FEATURING THE AMAZING ROTARY PSYCHO-OPTICON
at **ABC**

Commissioned by the Common Guild in collaboration with the Public Art Fund, New York
and in association with the Gi Festival 2008
Image: The Rodney Graham Band
Photo: Scott Livingstone

▸ www.thecommonguild.org.uk

THE COMMON GUILD presents **ADEL ABDESSEMED**
at **21 Woodlands Terrace**

Commissioned by the Common Guild in association with the Gi Festival 2008
Supported by The Elephant Trust
With thanks to the Alliance Française de Glasgow and the Institut français d'Ecosse.
Image: Adel Abdessemed, *Mes Amis*, 2005 (photograph)
Courtesy the artist and David Zwirner Gallery, New York

▸ www.thecommonguild.org.uk

'GIVEN TO THE PEOPLE' – SIMON YUILL
at GalGael Boatyard

Commissioned by the Gi festival 2008
Image: *Pollok Free State*, ©1994–1995 Citizens of the Pollok Free State

'Pollok Estate was given to the people in 1939, once given it cannae be ungiven,
it can only be stolen.' – Colin Macleod, *Pollok Free State*

▶ www.giventothepeople.org

'THE OTHER CHURCH' – WILHELM SASNAL
at 66–68 Osborne Street

Commissioned by the Gi Festival 2008
Image: Wilhelm Sasnal, *The Other Church*, 2008 (16mm stills)
Courtesy the artist

▸ www.glasgowinternational.org

'HINTERLAND' – HARALD TUREK
at Intermedia Gallery, CCA

Intermedia Gallery is programmed and funded through Culture and Sport Glasgow
Image: Harald Turek, *Hinterland*, 2007
Courtesy the artist

▸ www.haraldmelroseturek.com

'FOREVER CHANGES' – JIM LAMBIE
at GoMA

Commissioned by GoMA in association with the Gi Festival 2008
Supported by Culture and Sport Glasgow
Image: Jim Lambie, *The Byrds (Pressure Drop)*, 2005 (ceramic cockatoo, gloss paint, duct tape, spray paint)
Installation view, 'The Kinks', Turner Prize 2005 Exhibition, Tate Britain
Courtesy the artist, Sadie Coles HQ, London and The Modern Institute/Toby Webster Ltd, Glasgow

► www.glasgowmuseums.com

'IN TRANSIT' – DANI MARTI & KATRI WALKER
at 82–84 Saltmarket

Commissioned by the Gi Festival 2008 and supported by The Dewar Arts Awards, The Hope Scott Trust
and SAC Creative Development grant
TOP: Katri Walker, *Sr Celestino on the edge of Heaven* (video still)
BOTTOM: Dani Marti, *Under the Coollabah Tree* (video still)
Courtesy the artists, Breenspace, Sydney and Arc One Gallery, Melbourne

'ASKING FOR IT – EVERYDAY NEUROSIS IN CHINESE CONTEMPORARY ART'
at Mackintosh Gallery, Glasgow School of Art

Xu Zhen, Shi Qing, Liang Yuanwei, Chen Xiaoyun, Kan Xuan and Chu Yun

Commissioned by the Glasgow School of Art in association with the Gi Festival 2008
A collaboration with Beijing-based curators Pi Li (UniversalStudios-Beijing Boers-Li Gallery)
and Colin Chinnery (UCCA). The exhibition has been made possible through a China UK
Connections-through-Culture grant and support from China Now in Scotland.
Image: from Shi Qing, *List of Weaponry*, 2001 (each 60 × 60cm)

▸ www.gsa.ac.uk

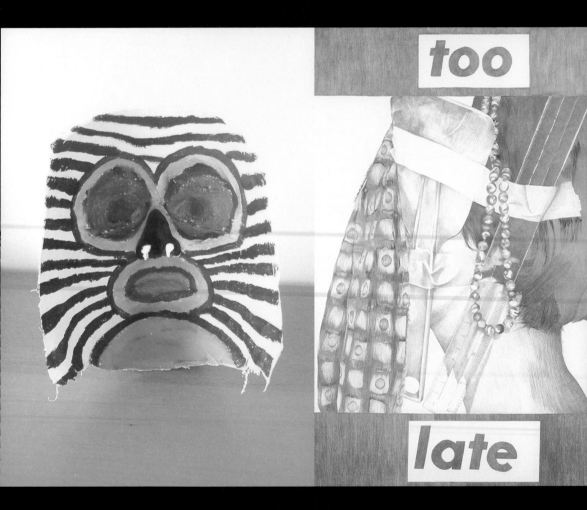

'OUR SORRY MINDS' – KATE DAVIS & NEIL BICKERTON
at **61 Parnie Street**

Image courtesy Neil Bickerton & Kate Davis

'THE MUNDANE SHELL' – SHARON THOMAS & LAURENCE FIGGIS
at **Glasgow Print Studio**

TOP: Laurence Figgis, *In Foucauldia*, 2007 (digital print on paper, 39 × 50cm)
BOTTOM: Sharon Thomas, *Apotropaic ('Don't You Fucking Mess With Me,' Said Little Red Riding Hood)*, 2005
(charcoal on paper, 100cm × 340cm)

▶ www.gpsart.co.uk · www.laurencefiggis.co.uk · www.sharonthomas.co.uk

THE MODERN INSTITUTE presents **SIMON STARLING**
at The Bath House, Osborne Street

Image: Thomas Annan, *High Street, Glasgow, 1868*, courtesy T & R Annan & Sons Ltd

▸ www.themoderninstitute.com

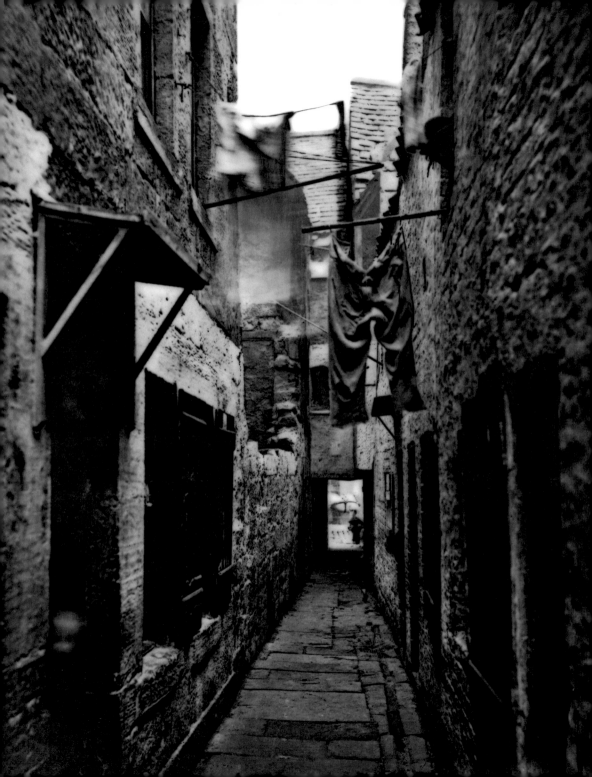

LOWSALT presents

BLACK FIRES' – IAIN KETTLES
at various temporary sites around Glasgow city centre

Between 7&13, Iain Kettles & Suzie Hunter, 1998 (right)

THE SECRET AGENT' – JUDD BRUCKE AND RAYDALE DOWER
A performance based on the Joseph Conrad novel
at various street locations

Image by Dower/Brucke, 2008 (below)

Commissioned by Lowsalt in association with the Gi Festival 2008

www.lowsalt.org.uk/gi2008

LOWSALT presents **'UVP (WORLDWIDE)'** – **ANDREW REID**
at **Lowsalt Gallery**

Commissioned by Lowsalt in association with the Gi festival 2008
Image by Andrew Reid, 2008

▸ www.lowsalt.org.uk/gi2008

MARIA DOYLE
at **Centro Español Lorca**

Image: Maria Doyle, Untitled
Courtesy the artist

ANTI-COOL, KATHY AOKI & HIDEKO INOUE
at Market Gallery

Commissioned by the Gi Festival 2008
Supported by The Great Britain Sasakawa Foundation
Image: Hideko Ineko, *Lamb*

▸ www.marketgallery.org.uk

'SOMETHING NO LESS IMPORTANT THAN NOTHING/NOTHING NO LESS IMPORTANT THAN SOMETHING'
JONATHAN MONK
at Tramway

Commissioned by Tramway in association with the Gi Festival 2008
Image: Jonathan Monk, *Another Fine Mess Repeated (out of sync)*, 2006 (16mm film, record player, projector, 2 plinths, amplifier and speaker)
Courtesy the artist and Lisson Gallery
Photo: Dave Morgan

▸ www.tramway.org

Commissioned by the Gi Festival 2008
Thanks to the SAC for their Creative & Professional Development Award 2007
directly supporting research into this project.
Image: Calum Stirling, *Rostra Plaza* studio image, 2007
Courtesy the artist

▸ www.modelcitizen.org.uk

'THE STATE'
A. Vermin at The State Bar

Jim Colquhoun, Grier Edmundson, Hrafnhildur Halldórsdóttir, Emmet Kierans, Ben Merris, Dan Monks, Stina Wirfelt, Kevin Pollock, Baldvin Ringsted
Curated by Alhena Katsof

Commissioned by A. Vermin in association with the Gi Festival 2008
A. Vermin would like to thank Nancy, Jason, The State Bar and The Hope Scott Trust for their generous and spirited support.
Photo: Stina Wirfelt

▸ www.avermin.org

'RECORDS PLAYED BACKWARDS'
at The Modern Institute

John Armleder, Justin Beal, Anne Collier, Céline Duval, Matias Faldbakken, Wade Guyton, William E Jones, Seth Price, Reena Spaulings/Bernadette Corporation/Claire Fontaine, Michael S. Riedel, Emily Sundblad and friends, Adolf Wölfli
Curated By Danial Baumann

Commissioned by The Modern Institute in association with the Gi Festival 2008
Image: Wade Guyton, *spray paint in Tbilsi*
Courtesy the artist and The Modern Institute Glasgow

▸ www.themoderninstitute.com

'BEYOND VISIBILITY' – T S BEALL, THOMAS JOSHUA COOPER, BALDVIN RINGSTED
at St Mungo Museum of Religious Life and Art & off-site location

Supported by The Glasgow University Centre for the Study of Literature, Theology and the Arts, The Diocese of Glasgow and Galloway
Thomas Joshua Cooper appears courtesy Haunch of Venison
Image: t s beall, *double blind*, 2008 (stills from 2-channel video installation)
Courtesy the artist

▶ www.artnews.net/baldvinringsted · www.haunchofvenison.com · www.stillstatic.org

'NOW AND THEN' – ALASDAIR GRAY
at Sorcha Dallas

Commissioned by Sorcha Dallas in association with the Gi Festival 2008
Image: Alasdair Gray, *The New Room*, 1972
Courtesy the artist & Sorcha Dallas

▸ www.sorchadallas.com

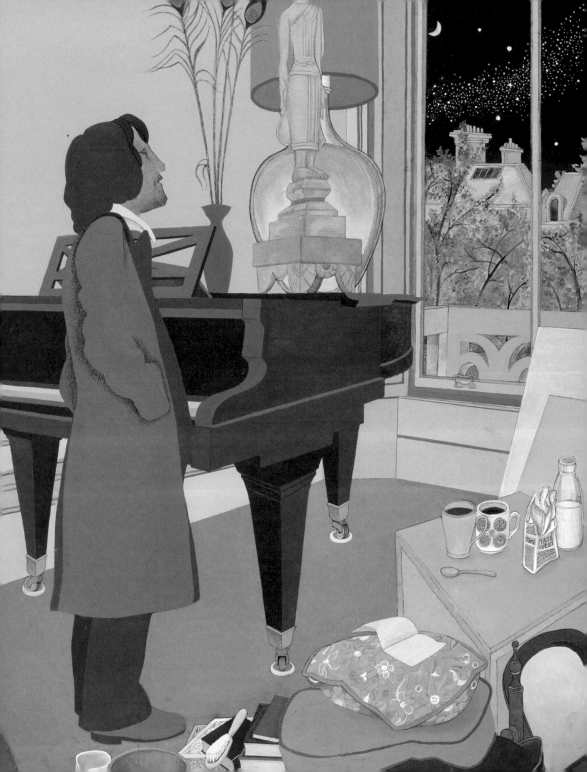

'CARRYING PRILM' – NATALIE MCILROY
at **Glasgow Print Studio**

Image: *White Ball*, 2008 (digital print)
Courtesy the artist

▸ www.gpsart.co.uk

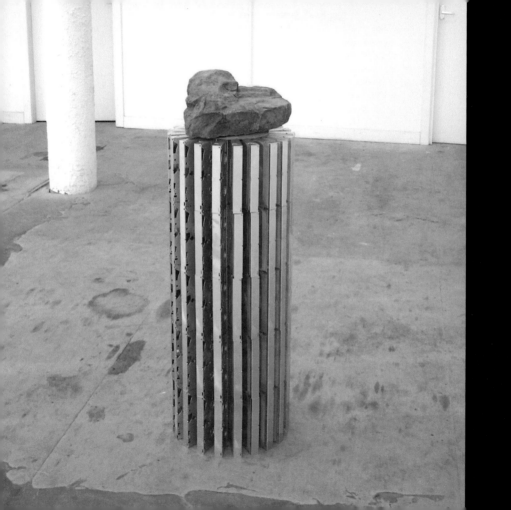

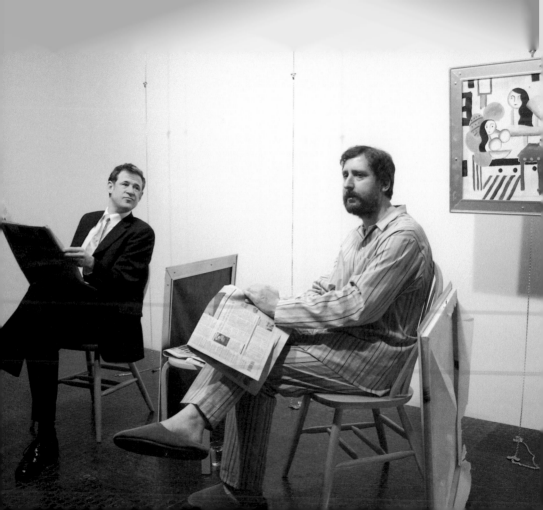

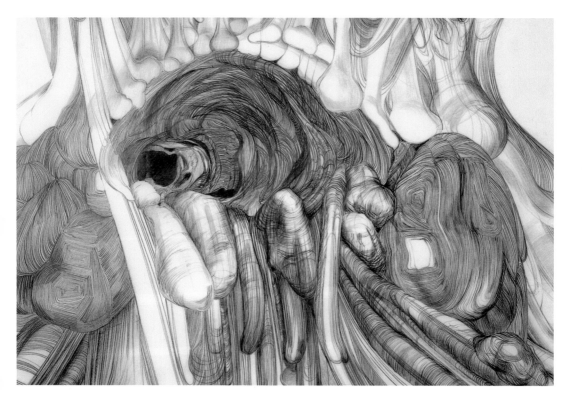

LUCIA KING
at **Q! Gallery & Studio**

Commissioned by Q! Gallery & Studio in association with the Gi Festival 2008
The artist's accommodation in Glasgow has kindly been sponsored by Fraser Suites Glasgow
Image: *Your improbable flesh*, 2007 (brown pencil on tracing paper)

▸ www.luciaking.co.uk

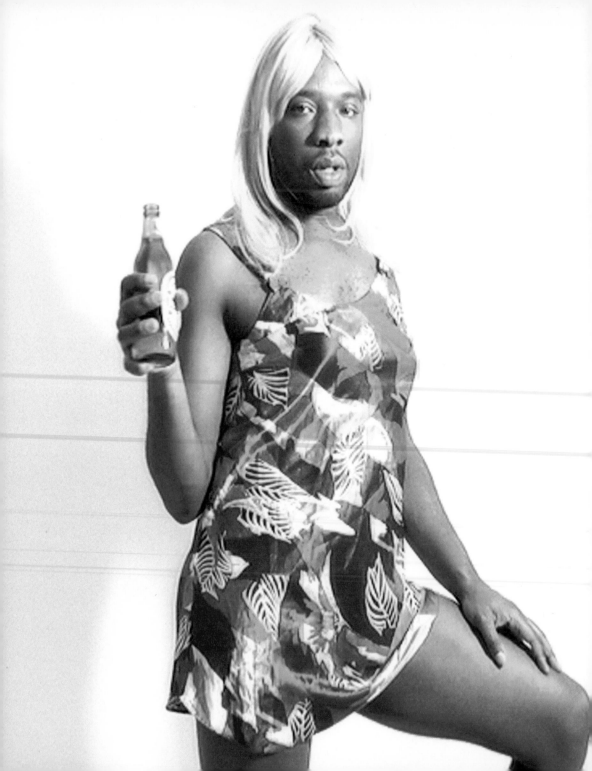

WASHINGTON GARCIA presents **KALUP LINZY**
at Washington Garcia off-site venue, 16 Trongate

Commissioned by Washington Garcia in association with the Gi Festival 2008
Thanks to Taxter & Spengermann, New York
Image: Kalup Linzy, *Chewing Gum (Katonya)* (still from *SweetBerry Sonnet*, 2008, digital video, 2' 34")
Courtesy the artist and Taxter & Spengemann, New York

▸ www.washingtongarciagallery.com · www.kaluplinzy.com

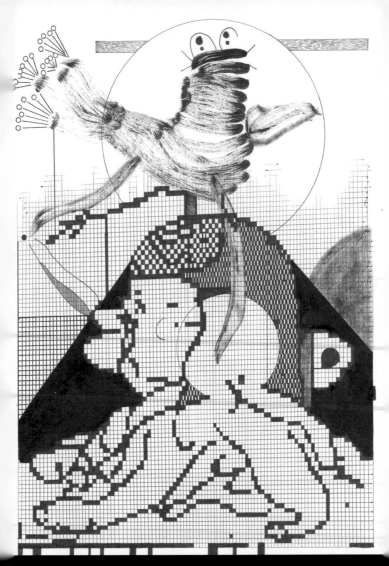

'RUN RUN RUN'
at The Collins Gallery

Laura Aldridge, Rob Churm, Richard Deacon, Roger Hiorns, Alex Frost, John Latham, Torsten Laus
Jason Meadows, Bernd Ribbeck, Pae White, Gregor Wright, Mary Redmond, Haegue Yang, Heim

Commissioned by Sorcha Dallas in association with the Gi Festival 2008

'CALEDONIA/CANAL ZONES' – ROGER PALMER
at **Wasps Artists' Studios**

Image: Roger Palmer, *Caledonia*, 2007
Courtesy the artist

▶ www.waspsstudios.org.uk · www.rogerpalmer.info

'THE LAST 3600 SECONDS OF WASP' – ZATORSKI + ZATORSKI
at The Fridge Gallery

Image: *The Last 3600 Seconds of Wasp*, 2004
Courtesy Zatorski + Zatorski

▶ www.southsidestudios.org

ANI BARONIAN, NIM WUNNAN
at 72 Gallowgate

Image: Nim Wunnan, *My Dream Girl Don't Exist*
Courtesy the artist

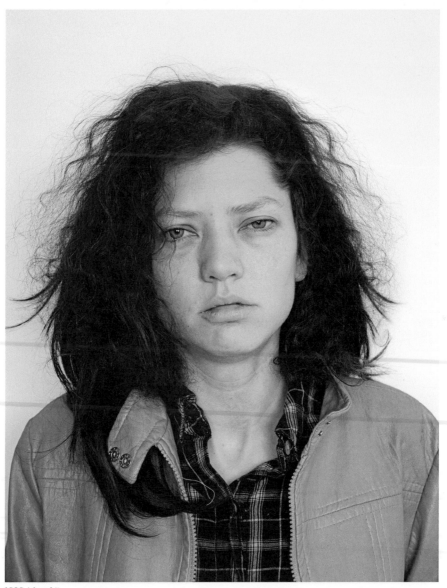

1986 / dread it

'TRY TO DO THINGS WE ALL CAN UNDERSTAND' – E J MAJOR
at Street Level Photoworks

Image courtesy the artist

▸ www.streetlevelphotoworks.org

STREET LEVEL presents 'THE CARAVAN GALLERY' – JAN WILLIAMS & CHRIS TEASDALE
at **various off-site venues**

Commissioned by Street Level in association with the Gi Festival 2008
Supported by Merchant City Initiative
Image: Caravan Gallery, *Rugs*

▸ www.streetlevelphotoworks.org

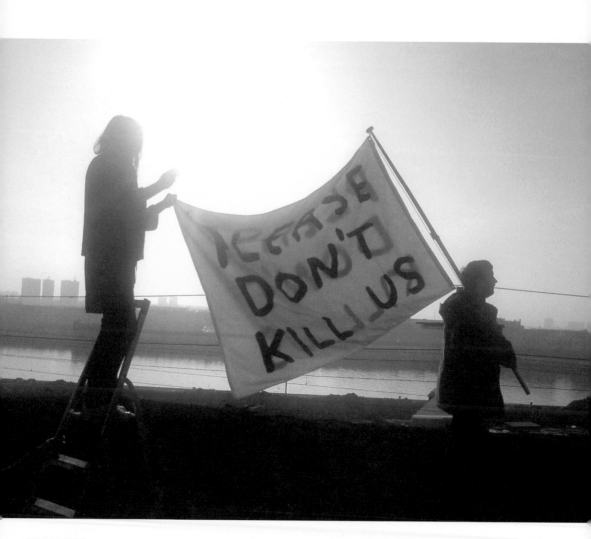

'THE LOCAL'
at SWG3 Studios

Fikret Atay, Assume Vivid Astro Focus, Rebecca Bolton, Sonia Boyce, Roderick Buchanan, Louise Chappell, Jacqueline Donachie, Gair Dunlop, Cerith Wyn Evans, Hatice Guleryuz, Jim Lambie, DJ Fabrizio Mammarella, Steff Norwood, Toby Paterson, Jennie Savage, David Shrigley, Sandy Smith, Superflex, Rirkrit Tiravanija, Sue Tompkins, DJ Craig Thompson, Timorous Beasties, Deryck Walker and SWG3 volunteers

Commissioned in association with the Gi Festival 2008
Supported by Arts Council England and sponsored by John Stevenson (Flags) Ltd, Nord Architecture and Norbord
Photo: Alan Miller (flag by David Shrigley)

▸ www.swg3.tv

'UNCLE CHOP CHOP'
at **The State Bar**

Dan Perjovschi, Beagles and Ramsay, Withered Hand, Jim Lambie, Erica Eyres, David Shrigley, Clara Ursitti, Plinky Plonk, David Burrows, Simon O'Sullivan, Sigga Bjorg Sigurdardottir, Danny Holcroft, Aliens Anonymous, Luke Collins, Fiona Jardine, Antonio Olaio, Owen Piper, David Sherry, Mick Peter, Rebecca Anson, Mark Gubb, Gordon Dalton and Ye Wax Dwarf

Supported by Edinburgh College of Art
Image courtesy Uncle Chop Chop

▶ www.unclechopchop.com

Talks, Studio Visits & Symposiums

MFA Open Studios. Photo: Ben Orion Rush

ARTISTS & TECHNOLOGY TALKS SERIES

Apple Store, Buchanan Street, 3, 10, 17, 24 April 7–8pm

Confirming the rumour that most visual artists, designers and video makers prefer Macs, young Glasgow-based artists present cutting edge contemporary art they have created with the help of Apple computers.

With thanks to Andy Unger

GLASGOW SCHOOL OF ART FRIDAY EVENT

Curators' Talk: Pi Li and Colin Chinnery

GFT, Friday 11 April, 11am–12:30pm

Beijing-based curators Pi Li (UniversalStudios-Beijing, BoersLi Gallery, Beijing) and Colin Chinnery (UCCA, Beijing) talk about the 'Asking For It—Everyday Neurosis in Chinese Contemporary Art' exhibition on show in the Mackintosh Gallery at Glasgow School of Art.

NINA MÖNTMANN: CURATOR'S TALK

CCA, Monday 14 April, 6.30pm

Nina Möntmann, author of Art and its Institutions: Current Conflicts, Critique and Collaborations will examine the changing conditions of art institutions, social spaces and our notions of the public sphere

Supported by Göethe Institut Glasgow

THE COMMON GUILD presents
DETOURS: ROTTERDAM
with Nicolaus Schafhausen

The Trades Hall of Glasgow, Thursday 17 April, 7–8pm

Nicolaus Schafhausen Director, Witte De With, Rotterdam and former director of the European Kunsthalle Project in Cologne and Frankfurter Kunstverein offers his perspective on the relationship between the visual arts institution and its location: how programmes develop for places.

Part of The Common Guild's on-going 'Detours' programme in conjunction with the Centre for Art in Social Contexts, Glasgow School of Art.

▸ www.thecommonguild.org.uk

BEYOND VISIBILITY: EXPLORING THE SPIRITUAL IN CONTEMPORARY ARTISTIC PRACTICE

St Mungo Museum of Religious Life and Art, Saturday 19 April, 10.30am–1pm

Spirituality is not currently a subject in the centre of the arena of artistic debate. In relation to the 'Beyond Visibility' exhibition (which features video installation by t s Beall, photographs by Thomas Joshua Cooper, and sound installation by Baldvin Ringsted) there will be a symposium discussing notions of place, vision, and spirituality within contemporary art practice. This symposium will examine how current artistic practice

engages and articulates the sacred. Speakers include Gregor Duncan (Dean of Diocese of Glasgow and Galloway since 1996), Werner Jeanrond (Professor of Divinity, Glasgow University) and Elizabeth Moignard (Professor of Classical Art and Archaeology, Glasgow University).

Our interpretation and understanding of the world around us is based largely on the words that describe it. This is especially true in the realm of the spiritual or sacred, in situations when what we are describing is beyond the realm of the visible. In its many manifestations, art sometimes has the ability to push words aside, to take their place when we are challenged by our inability to articulate, or find language to communicate the sacred. In situations when we may glimpse or feel there is something that remains unknown, beyond the margins of our field of vision. In these works, presented as part of the 'Beyond Visibility' exhibition, how we see things comes into question, and how we understand them and, perhaps later, come again to speak of them.

Supported by The Glasgow University Centre for the Study of Literature, Theology and the Arts, The Diocese of Glasgow and Galloway

GLASGOW SCHOOL OF ART MFA OPEN STUDIOS

Glasgow School of Art, Barnes Building and the McLellan Gallery, Saturday 19 April 3–9pm

The MFA department offers a unique opportunity for the public to experience firsthand the wealth of art being created in Glasgow's oldest and most important art institution. Meet established and emerging visual artists in their working environments and see their latest creations in their studios.

▸ www.gsa.ac.uk

GLASGOW SCULPTURE STUDIOS presents PRIVATE THOUGHTS AND PUBLIC SPACES; PUBLIC ACTS AND PRIVATE PLACES

CCA, Monday 21 April, 10am–4pm

'Private Thoughts and Public Spaces; Public Acts and Private Places' is a free public symposium that will examine the shifting relationships between what might be public, what may be private, and how that discussion impacts on contemporary sculptural practices.

Catalysed by both the curatorial theme of the 2008 Glasgow international and the work of renowned German artist and invited speaker Mischa Kuball, 'Private

Thoughts...' brings together a range of experts in their fields for a symposium of public thinking and private incitement.

The first decade of the 21st Century has revealed a complex territory where the lines between the public and the private do not seem impermeable. In the social experience of areas as diverse as technology, ideology, and landscape, it may seem that the distinctions between public and private are becoming routinely challenged, and their positions inverted. Has there been a substantive shift in this landscape, or is it our mapping of it that continues to evolve and change? What are the implications for how we chart the contemporary sculptural practices that exist within, challenge, and critique it?

As artists and others continue to navigate this capricious terrain, 'Private Thoughts...' will provide a platform for new perspectives and the questions they may raise.

Speakers include Pavel Büchler, David Harding, Claire Doherty and Mischa Kuball. Chaired by Ruth Barker.

'Private Thoughts and Public Spaces; Public Acts and Private Places' is a collaboration between CCA, The Gi Festival 2008, Glasgow Sculpture Studios, Göethe Institut & Public Art Resource + Research Scotland

▸ www.glasgowsculpturestudios.org · www.cca-glasgow.com · www.goethe.de/glasgow · www.glasgowinternational.org · www.publicartscotland.com · www.davidharding.net · www.situations.org.uk · www.mischakuball.com · www.ruthbarker.com

DECLAN MCGONAGLE: CURATOR'S TALK

CCA, Tuesday 22 April, 6.30pm

Irish curator and writer, Declan McGonagle, will discuss the issue of public and private in relation to public art works, arguing that they often articulate private codes rather than seek public engagement.

THE COMMON GUILD presents DETOURS: MELBOURNE with Juliana Engberg

The Trades Hall of Glasgow, Thursday 24 April, 7–8pm

Leading Australian curator Juliana Engberg has curated many international exhibitions, including the first Mebourne Biennial in 1999. She has been Artistic Director of ACCA (the Australian Centre for Contemporary Art) in Melbourne since opening in its landmark, custom-designed building in 2002. ACCA is the only major public

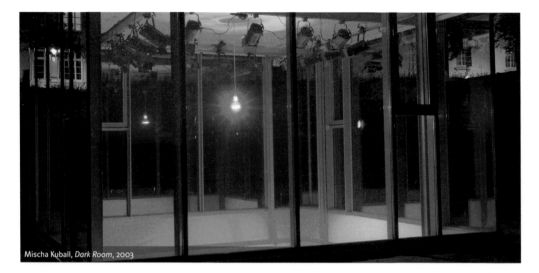

Mischa Kuball, *Dark Room*, 2003

art gallery in Australia focused on commissioning rather than collecting.

Event in association with VAGA.
Part of The Common Guild's ongoing 'Detours' programme in conjunction with the Centre for Art in Social Contexts, Glasgow School of Art.

▶ www.thecommonguild.org.uk

REPUTATIONS PUBLIC ART PROGRAMME
Book launch / artists' talk

Castlemilk Stables, Saturday 26 April, 3.30–5pm

Edwina fitzPatrick — *Art of Living*
Esther Shalev-Gerz — *A Thread*

Launch of two publications associated with the Reputations Public Art Programme in Castlemilk, Glasgow, with a roundtable discussion including the artists, writer Moira Jeffrey and Reputations co-curator Jason E. Bowman, and a reading from award-winning author Leslie Forbes.

Supported by Castlemilk Environment Trust, Scottish Arts Council, Lottery Fund, Culture and Sport Glasgow, Glasgow City Council Land and Environmental Services

▶ www.reputations.org.uk

WALLETO

Hitherto

For Glasgow international 2008, Hitherto has collaborated with Los Angeles-based Poketo to produce a series of collectable artists' wallets. Poketo have been producing limited edition wallets since 2003, using the designs of emerging illustrators/graphic artists in addition to commissions from museums which have included designs by Gilbert and George.

Poketo asked Hitherto to curate a 'Glasgow series' with artists whose work represents the diverse variety of illustrative styles that can be found in the city.

The following artists each designed a wallet exclusively for this series: MARC BAINES, a cartoonist, printmaker and publisher who also teaches illustration at Glasgow School of Art (GSA); ROB CHURM, a visual artist represented by Sorcha Dallas, whose posters are iconic in Glasgow's alternative music scene; REBECCA DAVIES, EMILY ROBERTSON, and EILIDH WEIR, all promising recent graduates from Visual Communication at GSA; STUART WHITE, co-founder of Plain Surface and major contributor to Hitherto; ANNABEL WRIGHT, who has illustrated for Penguin books, New Yorker and Amnesty International.

Walleto includes an exhibition of original artwork at Hitherto, as well as a launch party at Hitherto and SWG3 with performances from Belle and Sebastian's Stevie Jackson, Gummy Stumps, Correcto, and 1990s with visual accompaniment.

▶ www.hithertoshop.co.uk · www.poketo.com

Writers' Biographies

Alasdair Gray was born in Glasgow in 1934. He has worked as a teacher, painter, illustrator, playwright, scene painter, essayist, poet, novelist and muralist (the latest being the monumental decoration of Glasgow's Òran Mór). In Autumn 2008 *A Life In Pictures*, a visual biography of Gray's life and work, will be published by Canongate. He lives and works in Glasgow.

Luca Frei b.1976 Lugano, Switzerland, lives and works in Lund, Sweden
The so-called utopia of the centre beaubourg — An interpretation is the culmination of Luca Frei's fascination with and interest in Swiss sociologist Albert Meister's book *La soi-disant utopie du centre beaubourg*. This seminal text appeared under the pseudonym of Gustave Affeulpin in 1976, the year in which the real Centre Beaubourg in Paris was inaugurated. The book is a fictional account of the creation of a more than 70-storey, alternative centre beaubourg underneath the existing Parisian cultural centre.

F. Jardine currently lives in Glasgow

Melanie Gilligan, b. 1979 Toronto
Recent exhibitions include Greene Naftali Gallery and Orchard Gallery, New York, and the Serpentine Gallery and Tate Britain, London. She writes on topics including art, politics and finance for magazines such as *Texte zur Kunst*, *Artforum* and *Mute* and also writes fiction-essays and film scripts. She is part of the music groups Petit Mal and Antifamily.

Jan Verwoert is a contributing editor of *Frieze* and writes for various publications including *Frieze*, *Afterall* and *Metropolis M*. He is curator for 'Art Sheffield 08: Yes, No & Other Options' and he teaches at the Piet Zwart Institute, Rotterdam. His book, *Bas Jan Ader — In Search of the Miraculous*, was published in 2006 by Afterall Books/MIT Press.

Faith Wilding, b.1943 Paraguay, lives and works in Chicago
Wilding's work has been addressing feminist, social, political and cultural concerns since the late 1960s. She is Associate Professor of Performance at the School of Art Institute in Chicago and now works collaboratively with the cyberfeminist collective subRosa which she co-founded. She is currently participating in 'WACK! Art and the Feminist Revolution' at PS1, New York.

Kate Davis, b.1977 New Zealand, lives and works in Glasgow
Recent solo exhibitions include 'The clear stark vision is getting lost again', Galerie Kamm, Berlin (2007), 'Waiting in 1972; what about 2007?', Art Basel Statement with Sorcha Dallas, Basel, 2007, 'Your body is a battleground still', Art Now, Tate Britain, London, 2007. Upcoming exhibitions include 'Outsider' at Sorcha Dallas, Glasgow.

Babak Ghazi, b.1976 London
Recent solo presentations include Galerie Chez Valentin, Paris, Observatoire Maision Gregoire, Brussels and Whitechapel Project Space, London. His ongoing curatorial series Not Yet Night has been hosted by The Embassy, Edinburgh, Studio Voltaire, London and The Ship, London and he self-publishes the magazine Not-Yet. www.babakghazi.co.uk

The Gi Festival is produced and managed by Culture and Sport Glasgow. Gi is funded by Glasgow City Council, Event Scotland, Scottish Enterprise Glasgow, Scottish Arts Council, Culture and Sport Glasgow and Glasgow: Scotland with Style.

Gi wish to thank the following individuals and organisations for their support:
All staff at CCA; Artangel, in particular James Lingwood, Janette Scott, Rob Bowman and Tom Dingle; Barbara Absolon; Anne Bonnar; Charles Bell. Clare Simpson and all the Arts Development Team at Culture & Sport Glasgow; Sheyi Bankale; Amanda Catto; Kathryn Elkin; Emlyn Firth; Elaine Dickie, Moira Dyer, Nancy McLardie, Tom Rice and Scott Taylor at Glasgow City Marketing Bureau; Alison Jacques; Anne McFadden; Kirsty Price at Maxxium; Didier Pasquette; Allan Ruddiman and Claire Wishart at Sabre webdesign; Martin Breslin, Karin Finlay and Jane Montgomery at VisitScotland; Vicky Russell; Isla Wood

The Festival would not be possible without the commitment, vibrancy and enormous efforts of the Glasgow visual arts community.

Artistic Advisory Committee
Katie Bruce, GoMA; Gerry Grams, City Design Advisor, Glasgow City Council; Keith Hartley, Scottish National Galleries; Moira Jeffrey; Mark O'Neill, Culture & Sport Glasgow; Krisdy Shindler, Lowsalt; Toby Webster, The Modern Institute

Funders' Steering Group
Culture & Sport Glasgow; Mark O'Neill (chair) and Clare Simpson; EventScotland: Rebecca Esder; Glasgow City Marketing Bureau: Joe Aitken and Laura Nisbet; Scottish Arts Council: Stephen Palmer; Scottish Enterprise Glasgow: Mairi Bell

Glasgow international would like to say a huge thank you to all Festival volunteers.

Festival Team

Director:
Francis McKee

Producer:
Jean Cameron

Marketing & Promotions:
Vicki Anderson, Kelpie Communications

PR & Media Manager:
Lesley Booth, New Century PR

International Curators Coordinator:
Kim Coleman

Design:
Daniel Ibbotson, Graphical House

Festival Assistant:
Melanie Ingram

Corporate Liaison & Sponsorship:
Clare McLeod, Intermezzo Promotions

New Media and Press:
Alan Miller, Abnormal PR

Digital Communications:
Ben Rose, Sabre Webdesign

Volunteers & Festival Guests Liaison:
Karen Veitch

Gi Festival Office
c/o CCA
350 Sauchiehall Street
Glasgow
G2 3JD

www.glasgowinternational.org
e: info@glasgowinternational.org

t: +44 (0)141 352 4917

The Gi Festival would like to say thank you for the additional support received:
The Apple Store Glasgow; Argyll Hotel; Glasgow Restaurateurs' Association; Hotel de Vin; Jurys Inn; Malmaison Hotel; Millennium Hotel; The Skinny; Radisson Hotel; Striped Bass Restaurant; Robert Horne Group